BUILDINGS
OF NEW YORK

ROGER FITZGERALD

Artifice
books on architecture

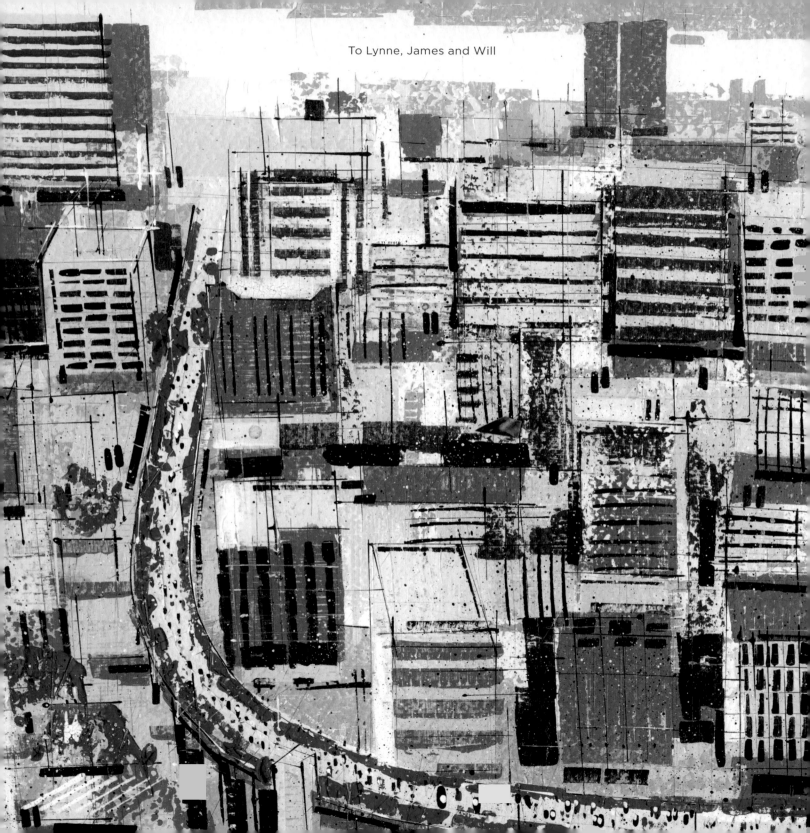

To Lynne, James and Will

CONTENTS

INTRODUCTION

The essence of New York is derived from its gridiron street pattern: lines of streets, running north–south, laid over avenues, orientated east–west. Much of the city's character arises from this simple, farsighted plan, established early in the nineteenth century.

The horizontal pattern of streets is rational and organized. Excitement comes in the third dimension as city blocks, or buildings within them that extend upwards: vertical lines reach into the sky, stretching technology, construction and the imagination to their limits. The result, best seen from the surrounding water or high vantage points, is a skyline that is impressive for its scale and unity.

New York is a global city, outward looking and cosmopolitan since it first began. Its growth, in large part through migration, has generated particular challenges, and without an orderly plan the result could have been environmental and social chaos. Equally, such regimentation—which might have given rise to a dull and authoritarian character—instead provides a framework within which one constantly discovers architectural surprises arising from the city's inherent diversity.

The city is rightly proud of its own history. Yes, it is progressive and constantly in flux, with buildings going up and down all the time, but it treasures its heritage too. Its formerly less desirable quarters, infrastructure and buildings—old warehouses, factories and railway lines—have been reinvented so that their quirky, gritty qualities are romanticized and sought-after.

The streets make New York a highly kinetic place. The characteristics of the urban environment help to define the energy and confidence of the city and its people. Competing needs of vehicles and pedestrians generate a stop-start rhythm for both to allow them to flow in turns. The grid only rarely makes way for green spaces such as churchyards, city squares or gardens. Everywhere else the streets are unbroken; the pace is relentless. You experience the city on the move.

Streets and avenues are numbered, which implies broadly equal status. In most other big cities there are wide main thoroughfares with narrow side streets, but not in Manhattan: here, every street is a main street, creating a single pace (allegretto!) and an unrelenting environment.

Not everything is regimented and controlled. The city's pluralist origins and culture have generated building types and styles that break rank, giving them extra status and attention. Whole districts, like Greenwich Village, were once separate settlements that predate the gridiron street plan and are quaintly different with curving streets and trendy shops. Meanwhile, in Brooklyn houses use colored paint and creative details to emphasize their uniqueness.

This breaking of regiment avoids any sense of authoritarianism, and the haphazard individualism makes New York vibrant and exciting. The underlying macro-structure and constancy of the buildings that do not break the mold generate an awesome scale to the backdrop. Within this framework, as well as the iconic and famous buildings, there are also the nonconforming and lesser known: the brownstone and timber-boarded houses; the contrasting buildings and spaces that delight and intrigue.

New York's colonial origins are still evident, and the city is notable within the United States as a classic, liberal East Coast city. What makes it distinctive on a global scale is how diversity and enterprise have been freely expressed within the constraints of a formal, citywide, grid-patterned development framework.

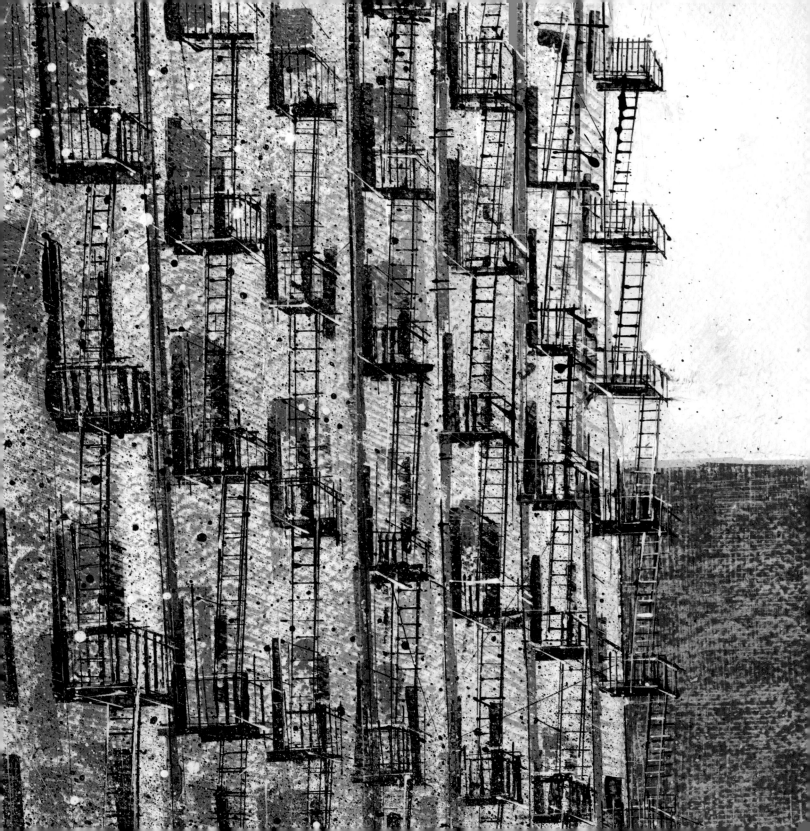

ORIGINS AND GROWTH

New York City owes its existence to its wonderful natural harbor—an inner bay within an outer bay—making this one of the world's finest examples of a port city. Sir Henry Hudson, an English explorer, discovered the site while working for the Dutch East India Company. A major river meanders inland for some 315 miles, connecting the port with its hinterland.

Many of the great cities of the world—such as London, Paris and Moscow—are split in two by their rivers, with distinct characters and even competition between one side and the other. Manhattan is different: water surrounds, defines and unifies the island itself, with outlying districts remaining separate and distinct.

Recognizing the potential of the area, in 1626 the Dutch purchased the island of Manhattan for 60 guilders and named the settlement New Amsterdam. Its success was soon reflected in its high density and packed buildings. Before long the Dutch were creating satellite settlements in Brooklyn and the Bronx.

On September 8, 1664, four English warships confronted the Dutch, and with its limited firepower New Amsterdam capitulated. It was renamed New York in recognition of the English naval commander the Duke of York, who would later become King James II.

The following years saw uprisings, invasions, protests and two major fires. Nonetheless, New York developed as a center of commerce, exploiting its excellent port and showing a willingness to innovate. An example of this was that boats would sail to a strict, reliable timetable, whether containing cargo or not. There was no waiting around until they were fully laden.

Old colonial New York occupied just the tip of the island. Its random street layout had Bowling Green, dominated by a fort, at its heart. From here, Broad Way—as the name implies, a particularly wide street—extended inland, now part of the present day Broadway. Stretching from one river to the other, a defensive wall followed the line of today's Wall Street.

Now devoured by development, the island of Manhattan was once cut into by bays and inlets. Hills, rocky outcrops, swamps and lakes, too, have all been obliterated by building work.

A canal—now Broad Street—was also cut into the island to aid the transportation of goods into the heart of the built-up area. Detached houses fronted the main thoroughfares with long formal gardens.

The footprint of New York was compact, extending just 15 or 20 blocks from the very tip of the island. Farmland lay beyond. The architecture was colonial with a mix of English, Dutch and French influences. Trinity Church was taller than anything around it.

Drawn by the promise of the new, millions made the epic journey across the Atlantic to land on Ellis Island, where they were 'processed' before being allowed into the country. They came from a dozen or so countries, and typically settled in poor communities on the Lower East Side—and, after ten years or so, many managed to move on.

After the destruction wreaked during the American Revolution and by several devastating fires, New York expanded rapidly. The Taylor-Roberts Plan, published in 1797, shows development on land owned by the Church and wealthy private families adopting planned, rectilinear street patterns. Old streets were widened, paved and renamed to remove associations with the British: this was part of the process of establishing independence and an American identity.

New York could expand in one direction only, since its origins were at the tip of the island. As growth rampaged northwards, it soon became clear that there needed to be an overall strategy. In 1807 a special commission was appointed by the state legislature to develop this. A survey was essential, and this job fell to John Randel Jr. The commissioners decided on a rectilinear layout for practical and functional reasons, and Randel drew this onto his survey. In 1811 the Commissioners' Plan was published.

The plan showed a vast street grid covering the entire island, making provisions for some 2,000 city blocks, an immensely ambitious template for urban growth. There have been subsequent changes—like the insertion of Central Park into the heart of uptown—but the essence has remained, laying down forever the essential character of New York. The legacy of this great plan is a city that is fundamentally orderly and organized, easy to navigate, and has impressive vistas along its longitudinal avenues or cross streets.

As the city grew in size and status, great civic and central landmarks were built. Classical architecture, inspired by ancient Rome and revived in Europe through the Renaissance, provided grandeur and decoration. Yet, fine as these buildings are, their overblown pomp betrays a lack of direction or confidence. The true spirit of the age is expressed by its great engineering projects: the railways, the dam and the aqueduct that brought fresh water to the city in 1842—the industries that were at New York's competitive cutting edge.

On January 1, 1898, New York and Brooklyn combined to form Greater New York City. Together with the Bronx, Queens and Staten Island they formed the second largest city in the world, after London.

After the First World War, New York acquired a glamorous social and cultural aura that was focused on Lower Manhattan and Greenwich Village, and a flourishing jazz scene in Harlem, which had become a hub for African Americans.

Later it was Midtown that became the focus of energy and excitement, with Park Avenue, famed for luxury goods; Madison Avenue, the home of advertising; Fifth Avenue, the wealthy commercial boulevard; and Broadway, the entertainment center.

Challenging periods followed. The effects of the Great Depression in the 1930s were counteracted as far as possible by investment in great municipal projects: parks, bridges, tunnels and swimming pools. In the 1960s and 1970s, civil unrest rooted in extreme personal poverty created slums and 'no-go' areas that contrasting starkly with general economic growth.

The city's resolve was tested as never before on Tuesday, September 11, 2001, when two airplanes were hijacked and flown into the Twin Towers with devastating effect. New York showed its resilience, first in grieving, then in rebuilding. Its people stood united.

Today's New York City has been reborn and reinvigorated. Its fundamental character is unaltered: the city constantly demonstrates an ability to grow and adapt; to face the unexpected and the unimaginable; and to emerge as a vibrant, diverse, intense, fast, big, noisy, successful and endlessly restless place.

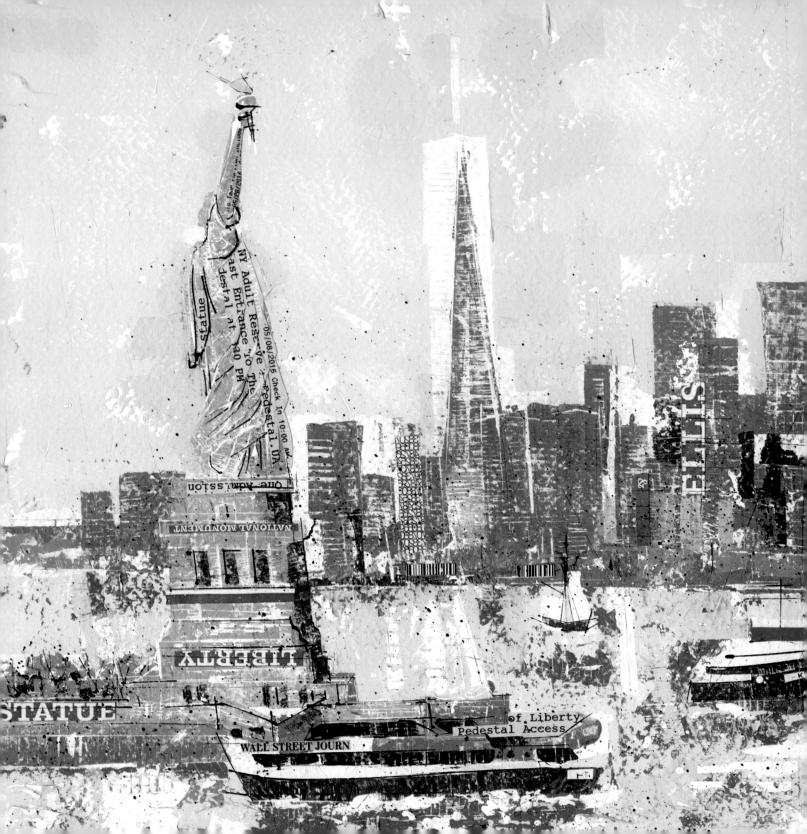

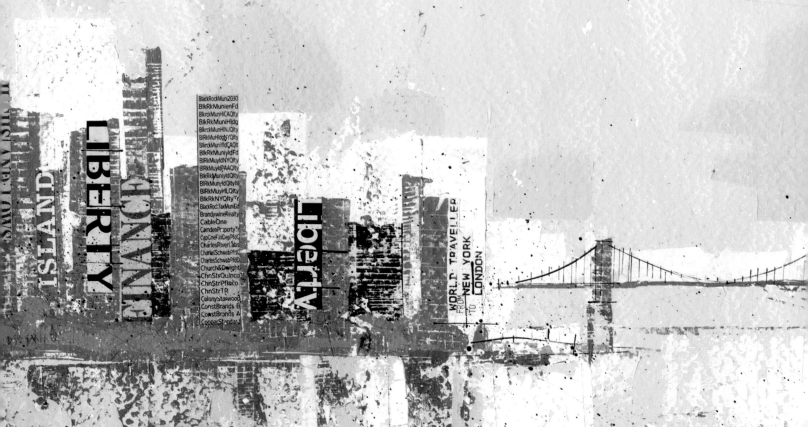

ISLAND

LIBERTY

CONVIL

Liberty

BlackRockMuni2030
BlkRkMunienFd
BlkrckMunHiCAQlty
BlkRkMuniHldg
BlkrckMunHINJQlty
BlRkMuHldgNYQlty
BlkrckMunYldCAQlt
BlkRkMunlyIdFd
BlRkMuyIdNYQlty
BlRkMuyIdPAAQlty
BlkRkMuniyIdQlty
BIRkMunyIdQltyIII
BlRKMuyirLQlty
BlkRkNYQltyTr
BlackRocTaxMuniBd
BrandywineRealty
CableOne
CamdenProperty T
CapOneFinDepPfdC
CharlesRiverLabs
CharlesSchwabPfd
CharlesSchwabPfdD
Church&Dwight
ChnStrQuinco
ChnStrPfIoco
ChnStrTR
ColonyStaswood
ConstBrands B
ConstBrands A
CooperStandard

WORLD TRAVELLER
FROM NEW YORK
TO LONDON

Castle Clinton National Monument

Castle Clinton is on the site of New York's earliest fortifications, built by the Dutch. A stronghold was depicted here in the Manatus map of 1639; its role was to provide defense from not only seafaring attacks but also the Indigenous population too. Known as the Southwest Battery, Castle Clinton was built between 1808 and 1811 on offshore rocks, joined by a timber causeway and drawbridge to the main island of Manhattan and used as a first line of defense against the British in the War of 1812.

Its original purpose of keeping people out was later reversed when it became an immigration entry point that welcomed people to the United States. Eight million people entered the country through this route between 1855 and 1890.

Ironically, the site still sees hordes of people flowing through security checks, but in the opposite direction. Now, this is the main embarkation point for sightseers on boat trips to the Statue of Liberty and Ellis Island.

Once a dominant building asserting its authority from a prominent headland, today the Castle is dwarfed by its backdrop of big office blocks. But, throughout the changes it has witnessed, the robust solidity of those deep red, eight-foot-thick sandstone walls has remained constant.

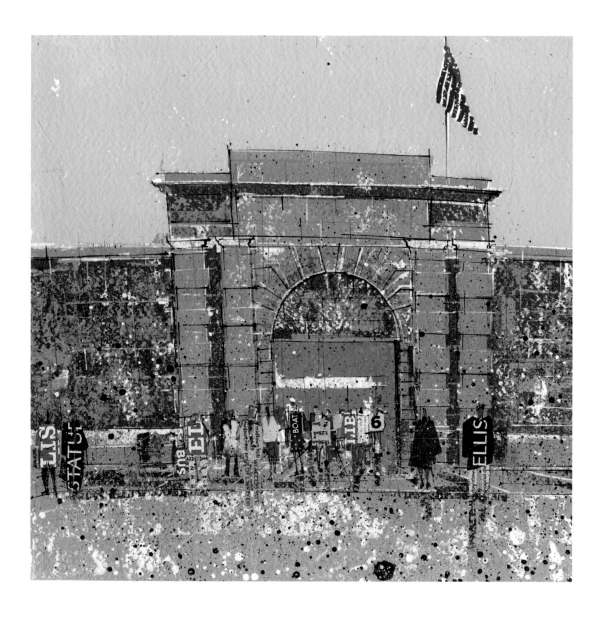

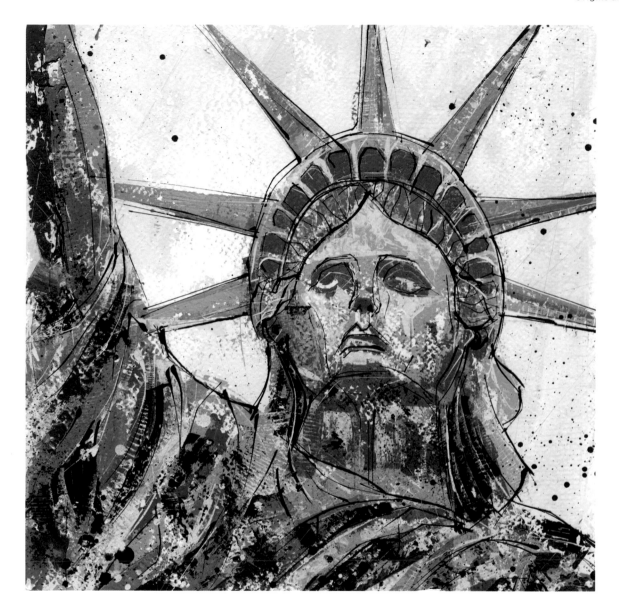

Statue of Liberty

Officially known as *Liberty Enlightening the World*, this gift from the French was completed in 1886 to mark the centenary of America's liberation from the British Empire. The statue was positioned with great care, orientated to be visible and welcoming to those arriving by sea, while also presenting a frontal view to the southern tip of Manhattan.

The statue's creation was a shared endeavor. Designed by Frédéric Auguste Bartholdi, it was formed out of enormous sheets of copper fixed to a structural frame devised by Alexandre Gustave Eiffel (of Parisian tower fame). It was fabricated in France and then shipped to New York.

The climb from the statue's pedestal up to the crown is unforgettable. Intertwined spiral staircases form the routes up and down, and as you weave your way up through the internal voids you can see the structural supports: heavy at the center, thin at the perimeter. It is a surreal space, reminiscent of the void one can climb through between the inner and outer domes of Brunelleschi's dome in Florence Cathedral.

Ellis Island Immigration Museum

Between 1892 and 1954, 12 million people, arriving by ship, landed on Ellis Island: a man-made landform created from spoil produced from excavations for New York subway's tunnels. The immigrants would have first passed the Statue of Liberty, its outstretched arm grasping a torch and symbolizing freedom.

The vast main hall needed to be large enough to process up to 4,000 people per day, but with its barrel vaulted ceiling it was also designed to impress and inspire. One can only imagine the emotions of hope or uncertainty experienced here by migrants. A small proportion had those expectations dashed straight away, as they were refused

entry on legal or medical grounds. In total 12 million people had passed through Ellis Island by the time it closed in 1954. This place saw those millions' first steps on American soil, and has become an area of great symbolic ancestral importance.

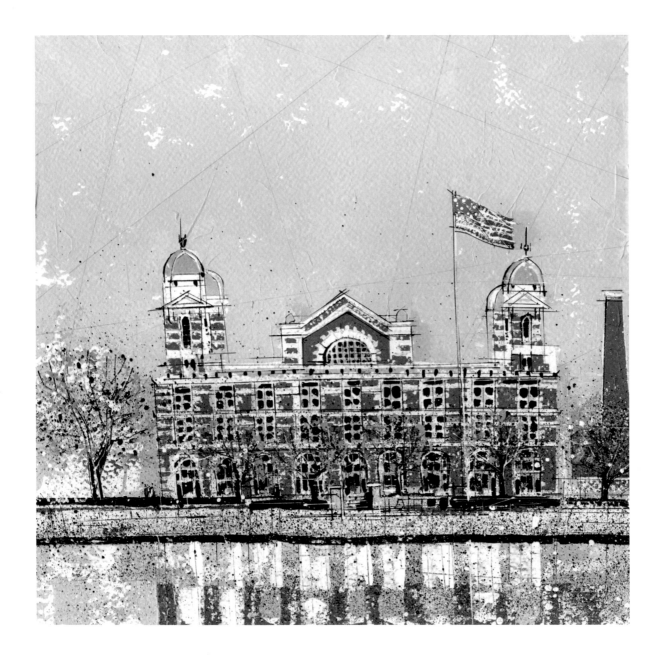

TRADE

Manhattan might now be famed for its skyscrapers and commerce, but its original source of wealth came about thanks to trade and the customs duties charged to those who used its greatest asset, the natural deep-water harbor. When the tip of the island was built up, its eastern side was the first to undergo intense development, as the East River became lined with quays and docks.

The southern tip of Manhattan is a site of great importance. The Indigenous Americans used this as a trading area, and later it was the location of the Dutch Fort Amsterdam. Since its formation in 1789, the New York Custom House occupied various premises including here, overlooking Manhattan's first park, Bowling Green.

The surviving Alexander Hamilton US Custom House of 1907 is a gem of the Beaux-Arts style, completed to Cass Gilbert's design. It would once have hummed with activity, as America's busiest harbor needed hundreds of customs agents to negotiate tariffs with ships' captains.

As trade developed, food markets emerged as an important building type in the early eighteenth century, and by the nineteenth they had consolidated into a few specialist markets in Lower Manhattan with trades concentrated together. The Commissioners' Plan of 1811 had recommended this, suggesting that the fixing and equalizing of prices—not to mention the convenience of similar outlets clustering together—would help purchasers save time. Washington Market, in what is now known as Tribeca, was the center for fruit and produce, while Gansevoort Market (originally known as the "Farmers' Market") was the focus for the meat trade. Its slaughterhouses and packing factories comprised an area that became known as the Meatpacking District. Fish markets developed near the docks of the Lower East Side.

While these commercial markets could cater for the million or so inhabitants of the city in the middle of the nineteenth century, 100 years later the population had grown eightfold. Not only were the markets unable to deal with the transportation, storage and preparation of food to satisfy so many people, they also occupied prime real estate. In 1967 Washington Market moved out to Hunts Point, Bronx, vacating land that would one day house the World Trade Center. The exodus continued with the meat traders in 1972 and, eventually, the fish market in 2005.

Trade attracted investors, and so emerged the development of the commercial center around Wall Street. The New York Stock Exchange began with the Buttonwood Agreement, signed by 24 stockbrokers in 1792. Just as London saw the creation of Lloyds Insurance in a coffee house, New York's very own Tontine Coffee House was built by stockbrokers as a venue for business. This included trading shares and sharing gossip but also, notoriously, the trafficking of slaves.

Today's New York City is a world leader in retail trade. The growth in online shopping has manifested not in the disappearance of retailers but in the modern use of physical space to raise 'brand awareness'. Department stores—with Macy's at the forefront—retain relevance partly as destinations and experiences. Similarly, street markets (as seen in Chinatown on the Lower East Side) still brim with fruit and vegetables, serving both the local community and tourists. Chelsea Market is another example of a quasi-real market experience.

In a city subject to constant renewal and growth, to keep pace with changing fashions and trading trends, it is important to identify and preserve the heritage of significant historic neighborhoods, buildings and public spaces. Brooklyn Heights was the first designated historic district in New York City, and many other neighborhoods have followed.

Harbor and Meatpacking District

Some buildings retain the same use for centuries; others have to reinvent themselves. The warehouses of the Meatpacking District on the western side of Manhattan served their original function for a relatively brief period and are now being converted into apartments. What began as a busy working environment is now a trendy quarter with hotels, bars and clubs.

The design challenge is to achieve the desired commercial regeneration without losing the area's gritty, historic character. The answer seems to be to keep the relics and patina of the bygone age in situ as discreet clues to the original functions of the warehouses. The wharves, cranes, rusting machinery, peeling brickwork—all of these give an insight into lives once lived.

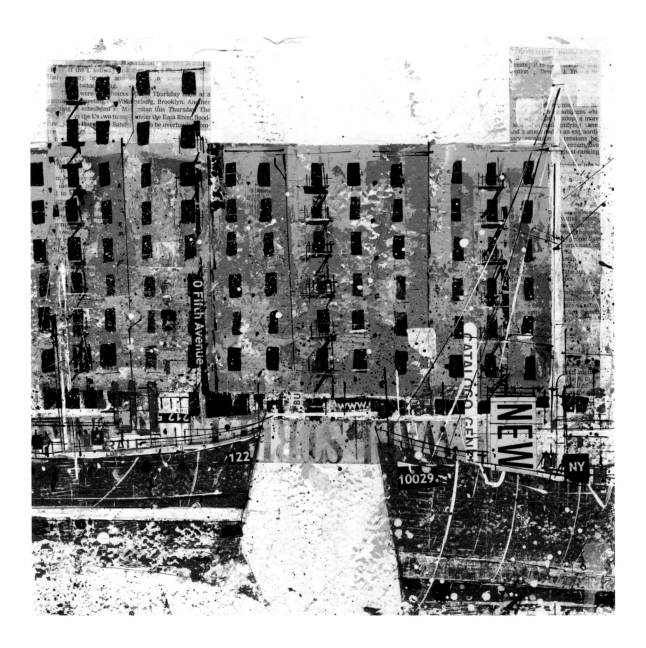

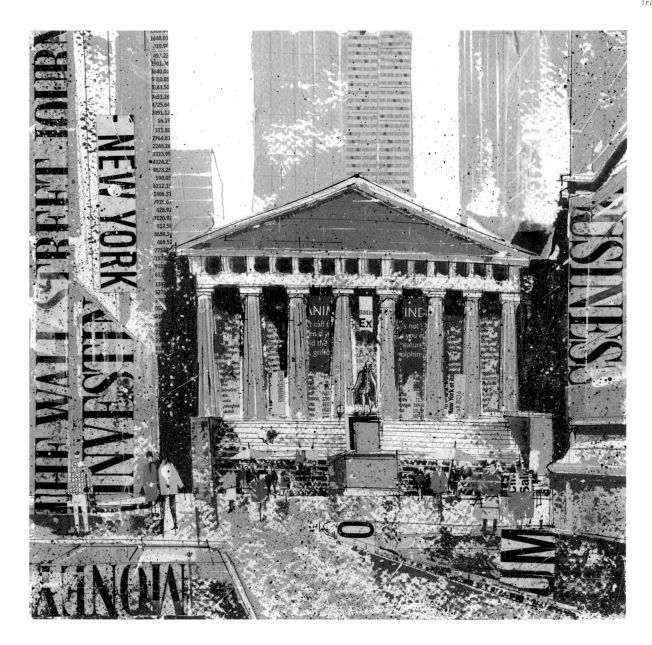

Federal Hall National Memorial

Wall Street is primarily known as the heart of New York's financial district, but it is also significant as the site where America's federal government began. The old Federal Hall once stood here, and on the balcony on April 30, 1789 George Washington was sworn in as the first President of the United States. The Bill of Rights was also adopted here.

The present building, well proportioned in a Greek Revival style, was built in 1842 as the Custom House for the port of New York. Its elegant rotunda now houses tourist activities and exhibitions.

18–20 Christopher Street

At the heart of the Greenwich Village neighborhood this pair of houses was built by Daniel Simonson in 1827. At the time they lay outside New York's built-up core, which was prone to outbreaks of yellow fever and cholera. The air here—to the north—was clean.

They are rather nicely detailed. The eight-paneled entrance doors are embellished with decorative surrounds, and above there is an overlight (number 20) and fanlight (number 18). The shopfronts—non-original—are cantilevered out with ornate corner supports, lending them a village-like rusticity.

At rooftop level the dual-pitched dormers unify three windows that are normally separate into a single, somewhat oversized element. This maximizes the attic headroom, floor space and light. The structure is struggling to cope with the weight, so the dormers have sunk somewhat into the surrounding roof—but that just adds to the quaint effect.

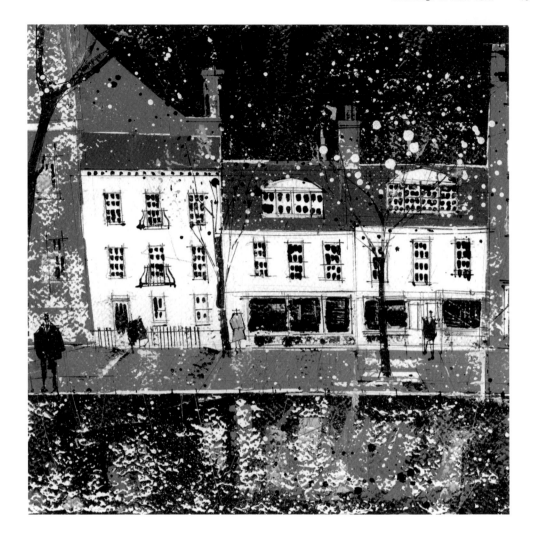

Baxter Street/Canal Street, Chinatown

Canal Street follows the line of what was once a drainage channel—little more than an open sewer until it was covered over in 1821. This was a seedy, dangerous gangland area. Now it is at the heart of Chinatown, a cacophony of market stalls, shops, signs, colors, scents and noises.

It markets itself as offering the community a new 'lifestyle experience'. The frontages of the buildings do not really register: one's focus is with the market stalls at street level.

The Apple Cube

When it was completed in 1968, the General Motors Building was set back from Fifth Avenue, creating a large and mostly underused plaza. The opportunity was brilliantly exploited by Steve Jobs of Apple and the owner of the GM Building, Harry Macklowe.

A 30-foot glass cube, perfectly sized for the space, was built in 2006 in the center of the plaza. Beyond the entrance, stairs and an elevator lead down to a vast, white and unworldly retail space. The original iteration used 90 pieces of glass, but was replaced in a $6.7 million overhaul in 2011 with something more sophisticated that rationalized the design down to just 15 panes. I usually think of buildings as being permanent creations, but here is architecture just as replaceable as an iPhone.

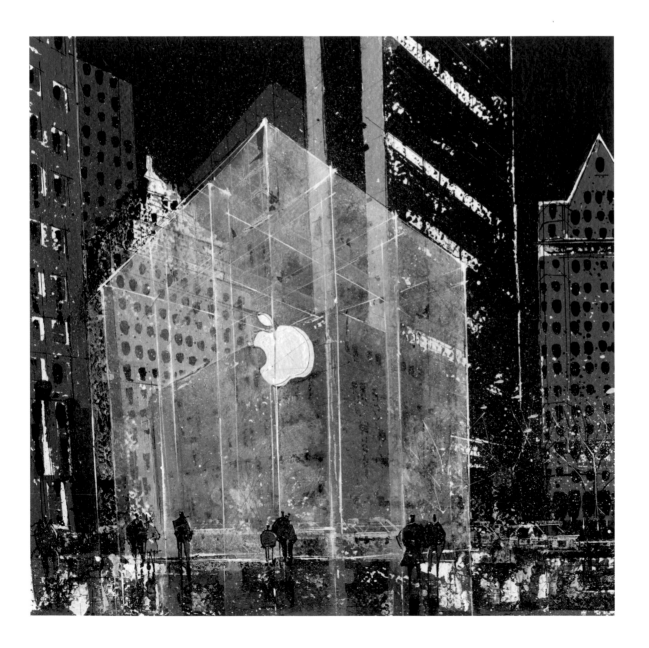

TRANSPORT

The importance of waterborne transportation for moving goods and people is demonstrated by the fact that—in spite of the city already being surrounded by water—early settlers in the 1600s went to the trouble of constructing a canal to penetrate deep into the heart of lower Manhattan. This followed the line of what is today Broad Street, having been infilled in 1676.

Water remained the primary means of moving bulky goods in the early nineteenth century, when it became expedient to improve links from the American Midwest to New York, from which one could access the markets of Europe. This aim was fulfilled by the construction of the 363-mile (now extended to 524 miles) Erie Canal, opened in 1825. Innovation and investment were brought to sea transport as well; the fastest clippers on the seas with the most elegant and efficient hulls came to serve this port.

Early roads for horses and wagons in Manhattan would have been unpaved. By the seventeenth century cobblestones were used (some 15 miles of cobbled streets still survive). Historic maps show that roads served the quaysides, running parallel with and perpendicular to the river frontages. As New York expanded, an even more formal rectilinear road pattern developed.

As New York expanded rapidly and people no longer lived where they worked, the need for a public transportation system emerged. Trains—first steam powered, then electrical—came into the city. Pennsylvania ("Penn") Station and Grand Central provided the great railway termini.

When Grand Central Terminal was built in 1871, it was located some distance from the heart of the city, to keep the steam engine fumes well away from the 1.4 million people who lived at the south end of Manhattan. But the railway hub acted as a magnet, attracting new growth in the underdeveloped surrounding area and speeding up the northward expansion of the city.

The idea of elevated tracks built above street level was mooted, and Charles Harvey pioneered the first such design, testing it in 1867. Several of the great avenues had elevated railways built above them (Second, Third, Sixth and Ninth). Where they remain, these raised transit systems bring vitality to the streetscape in the form of industrial, noisy, metallic movement.

As Manhattan Island was developed, New York needed an underground railway system. Work began on the New York City subway in 1900; its first section linked City Hall in Lower Manhattan to Harlem and was completed four years later. The subway then expanded rapidly. Much of the network was created by the technique of 'cut and cover' (in which tunnels are excavated following the lines of roads above, and are then covered over) rather than by boring tunnels. As a result, the subway is close to the surface, making it quicker and easier to access than many other underground systems across the world, which have been tunneled at much greater depth.

The architectural styling of the stations is simple and expressive of the subway's construction. Typically, flat concrete soffits are supported on a steel frame of columns and beams; station signs are bold and simple. This utilitarian approach is echoed in the design of the train carriages themselves.

As a means of transporting a lot of people efficiently, the subway is a success: there are 468 stations, 26 lines and 660 miles of track, and 4.5 million passengers use it every day.

Grand Central Terminal

The first station on this site was opened in 1871, but an accident in 1902 changed its future. Two steam trains collided in the subterranean approach, causing 15 deaths. The station was rebuilt to Warren & Wetmore's design, which gave rise to a fabulous concourse with an arched vaulted ceiling that spans 44 platforms. The platforms were put underground, taking advantage of the fact that innovative electric trains gave out less pollution than the old steam locomotives.

Stacked over two levels, this is one of the busiest railway stations in the world. Today, most of those who use the station are commuters who come in to New York for work, but previously the station has acted as a gateway to the rest of the country: a place not of arrival but departure for millions of migrants heading west for a new life.

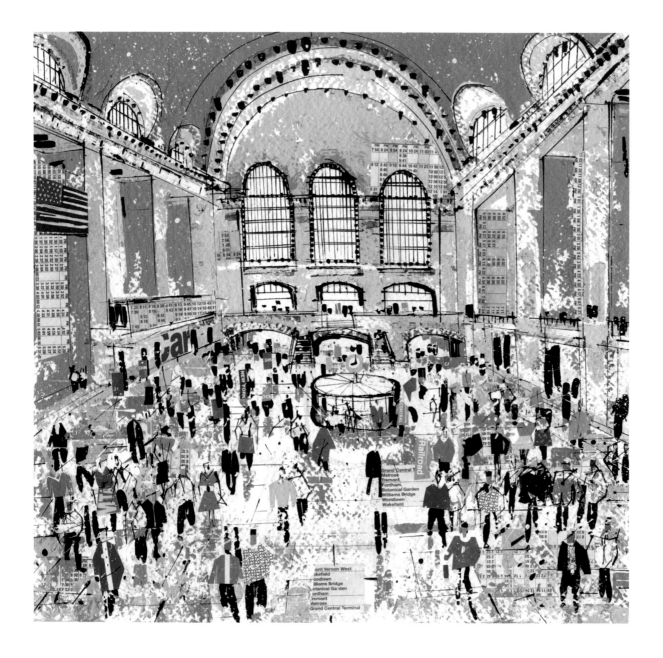

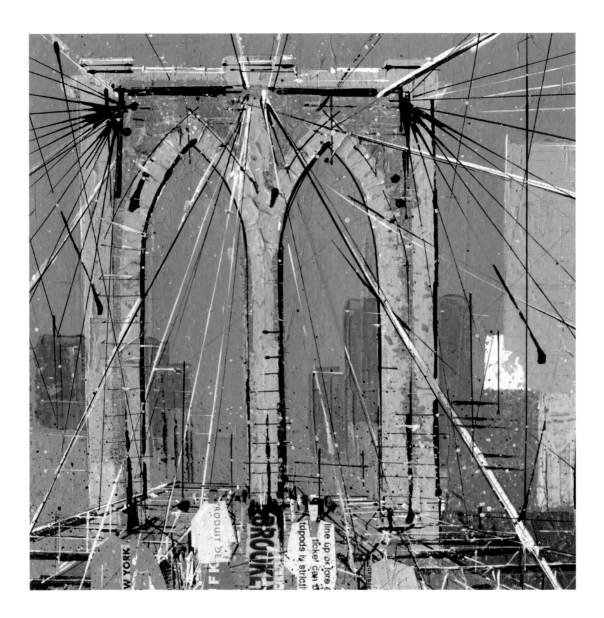

Brooklyn Bridge

The Brooklyn Bridge opened on May 24, 1883, crossing the East River to link Manhattan with Brooklyn. The full length is over one mile with the span of the central suspended section measuring some 1,595 feet. On its opening it was the longest bridge in the world. In the center is a raised walkway for pedestrians and cyclists. On either side below, carried by steel trusses and crossbeams, are the carriageways, originally for horse-drawn carriages and trains, now providing three lanes for motor vehicles.

The two towers are built in granite with pairs of Gothic arched openings. The main cables are huge at 16 inches in diameter; hanging from these are thinner sub-cables which carry the structure below. For good measure extra diagonal cables ensure the bridge's stability.

The bridge is associated with a number of tragic stories. During its construction its designer, John Augustus Roebling, a German immigrant, contracted tetanus and died after his foot was crushed while he was surveying another site. Later, Roebling's son Washington suffered a paralyzing illness as a result of decompression sickness that developed while he was excavating the foundations, obliging his wife, Emily, to take over his chief engineer duties for the following 14 years. Several workers also died in the construction of the bridge, and soon after its opening a fear that the bridge was collapsing led to a panicked stampede and further loss of life.

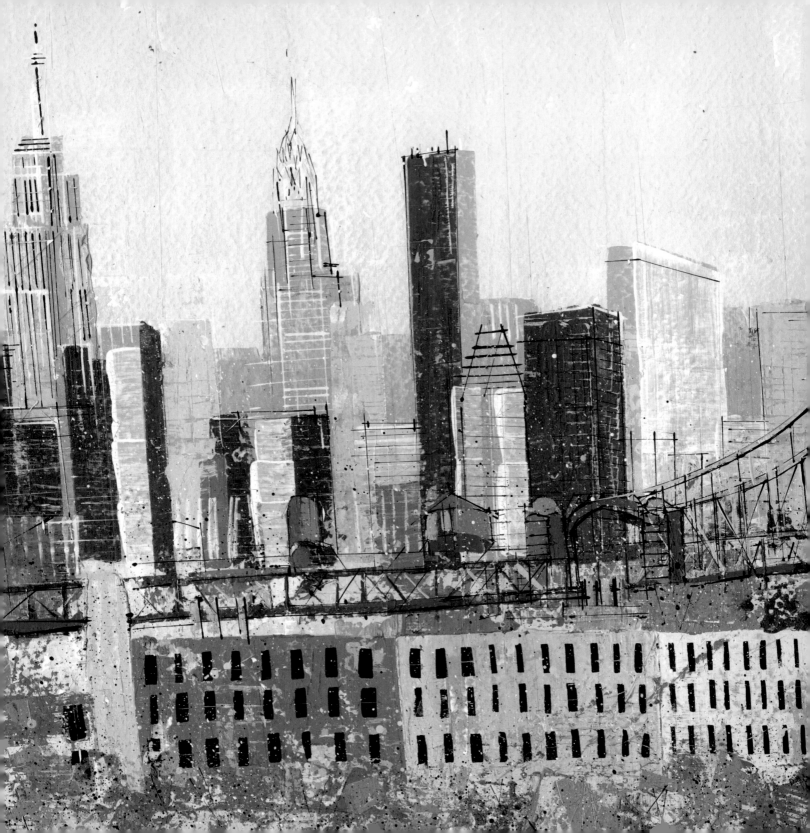

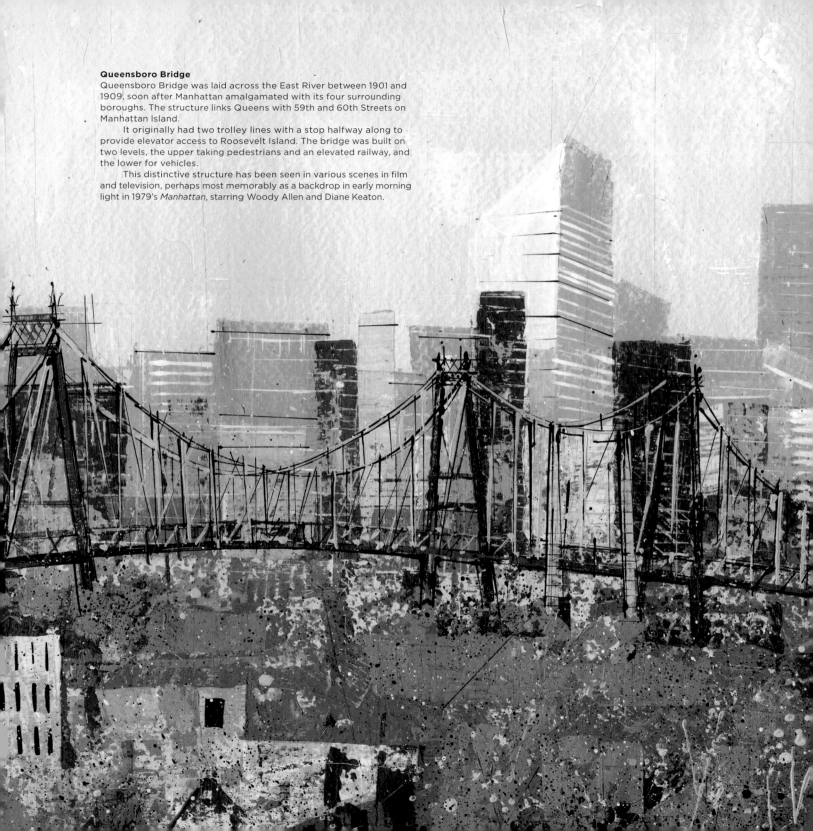

Queensboro Bridge
Queensboro Bridge was laid across the East River between 1901 and 1909, soon after Manhattan amalgamated with its four surrounding boroughs. The structure links Queens with 59th and 60th Streets on Manhattan Island.

It originally had two trolley lines with a stop halfway along to provide elevator access to Roosevelt Island. The bridge was built on two levels, the upper taking pedestrians and an elevated railway, and the lower for vehicles.

This distinctive structure has been seen in various scenes in film and television, perhaps most memorably as a backdrop in early morning light in 1979's *Manhattan*, starring Woody Allen and Diane Keaton.

Queensboro Plaza (New York City Subway)
This was the most elevated subway stop I could find. Its spaghetti-like tangle of metalwork supports two separate levels of railway tracks with platforms and staircases that connect passageways and booking halls.

As trains screech along the rails you can feel the whole platform sway. Below, visible between the structural supports, cars pollute the air. The effect is loud, toxic and unforgiving; bizarrely (and, I confess, ridiculously), I love this station in spite of itself.

COMMERCE

The explosion of commerce in New York happened after a period of internal unrest caused by the American Civil War from 1861 to 1865. It was only after conflict ended that the US could focus on rapidly increasing its global trade and importance. Driving its business success was New York.

Picture the city in the late nineteenth century: long piers projected out on either side of the island, into the East and the Hudson Rivers. The docks were lined with warehouses, factories and markets. In and around Wall Street were financiers, insurers, accountants, lawyers and printers. Besides the Battery (at the island's southern tip) and a couple of other open spaces (on either side of its central spine, Broadway), the whole southern part of Manhattan was densely developed and devoted to commercial enterprise.

A similar pattern can be traced in the city's industrial history. Initially growth was piecemeal with freight yards, manufacturing and residential neighborhoods juxtaposed. As heavy industry grew in scale, and people demanded better living conditions, they were separated into bespoke districts. Housing remained intertwined with lighter industries: workshops for joinery, metalworking and masonry, or distilleries.

With our modern, globally accessible instant messaging tools it is difficult to imagine how business was conducted a century or so ago. Communication was just as essential. Before the telephone was invented, being in close proximity to other businesses was vital—and that drove high-density development.

With limited space available the only option was to build high. Here, the city was helped by the innovations in steel production patented in 1855 by Englishman Henry Bessemer—and, of course, by the invention of the elevator. Confidence drove real estate values sky high, and skyscrapers—vertical symbols of capitalism—became viable for the first time.

Coinciding with the city's commercial success, new construction methods were transforming design thinking.

Until then, building facades featured a roughly equal balance between openings for windows and the load-bearing masonry required to support the walling above. Steel-framed buildings changed all this, separating the cladding system from a supporting function. Windows could now dominate the elevation with only slender subdivisions in between. Completed in 1899, Louis Sullivan's Bayard-Condict Building was one of the first to exploit the evolution of facades in skyscraper design, and subsequent buildings sought further innovations.

The 1920s saw a heady aesthetic combination of the desire to build high and the Art Deco stylistic movement. Apparently self-contradictory, the result was some iconic buildings with unique and recognizable silhouettes. Take Raymond Hood's design for the American Radiator and Standard Sanitary Company, built between 1923 and 1924. It is a bizarre but distinctive amalgamation of an Art Deco stepped profile—with some Gothic detailing thrown in—to achieve the fundamentally Modernist aim of building repetitive floors on many levels.

As New York City grew, so did the amount of time and money afforded to leisure and shopping. Towards the end of the nineteenth century, the retailing paradise of Ladies' Mile sprang up, offering women the chance to shop till they dropped, unaccompanied by men, in a safe and attractive environment. Department stores, dry goods emporiums, restaurants and performance venues all located themselves in an area to the south of Madison Square Park, the Chelsea and Flatiron neighborhoods.

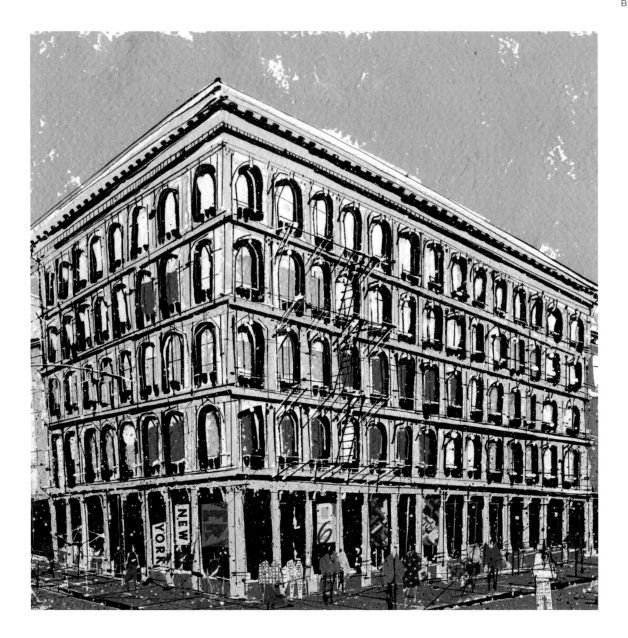

Haughwout Building

Beautifully composed and proportioned, the Haughwout Building was built in 1857 to the design of architect John P Gaynor. His inspiration came from Renaissance architecture in Venice, like Jacopo Sansovino's National Library and its arcaded elevations that face St Mark's Square.

The two street facades are composed of cast-iron components forged in the leading foundry of the day, the Architectural Iron Works. By then, cast iron was relatively cheap and readily available. The building housed the first commercial Otis elevator, which was hydraulically operated.

This was, therefore, the setting for a curious but fine mix of innovations with a derivative Italian Renaissance styling. The contents were eclectic too; the lower three levels were showrooms for home furnishings, while the upper two floors were used by craftsmen and craftswomen who were skilled in hand-painting china, silver-plating and glass-cutting.

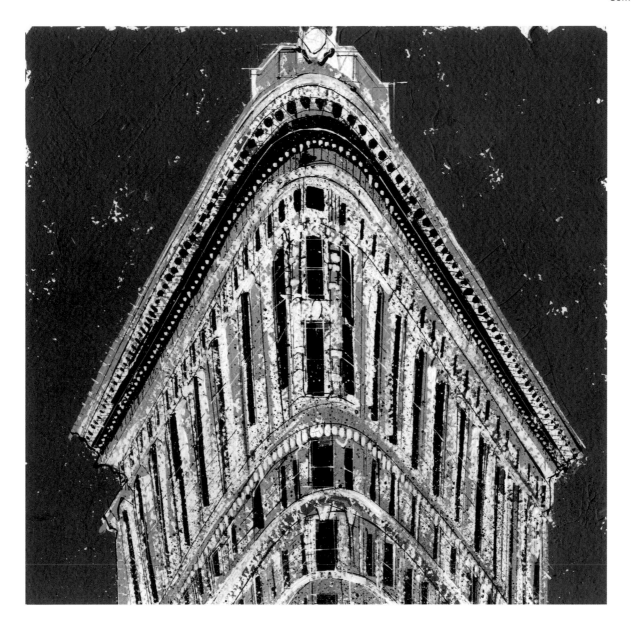

Flatiron Building

This is a magnificent building in so many ways. I particularly love the way its form responds to its site, its triangular shape determined by the angular intersection of Broadway and Fifth Avenue. Officially named the Fuller Building, it inevitably became known by its distinctive shape.

It is a confident piece of architecture. Its aim was to instigate more development in this Midtown district, and it employed a steel frame that was clad with generously proportioned ornate stone and terracotta detailing. Designed by Daniel H Burnham and built in 1902, its 21 floors give it a claim to being New York's oldest skyscraper, not just one of its finest.

Woolworth Building

A spectacular corporate statement when completed in 1913, Cass Gilbert's design for Frank W Woolworth appears simple and repetitive at a glance, and yet on closer inspection is found to be finessed with Gothic detailing, including gargoyles and other carved figures. However, it is the stepped profile, which anticipates the American Radiator Building and other Art Deco structures, that is most distinctive.

The Gothic finials and crockets are overscaled so they can be seen from street level. The top of the tower has a steeply pitched green copper pyramid. It was the tallest skyscraper in New York until 1930.

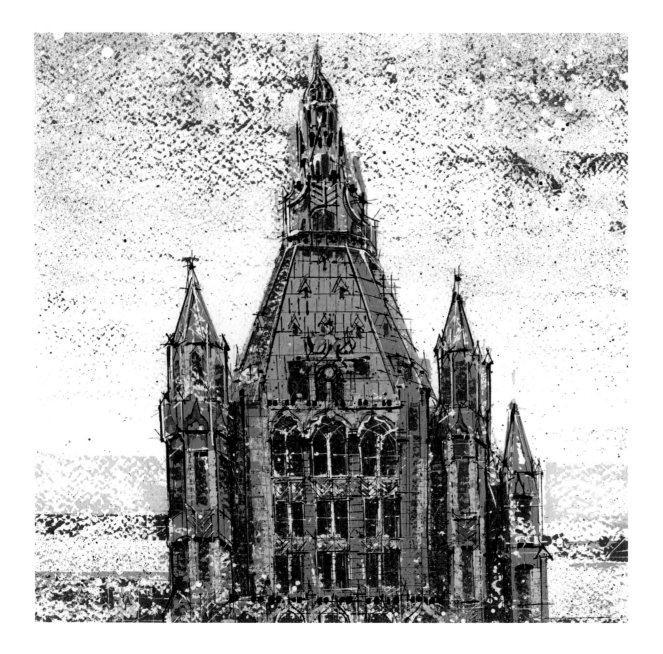

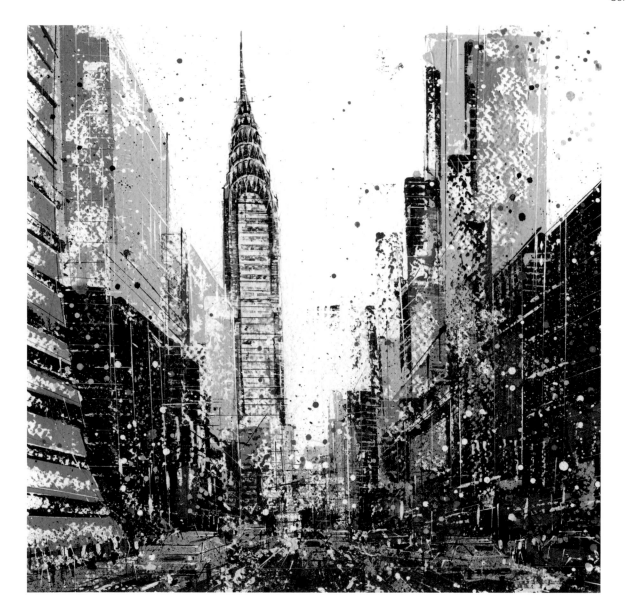

Chrysler Building

When completed in 1930, this was momentarily the world's tallest building at 1,048 feet, until it was surpassed just a year later by the Empire State Building. No matter: it remains shapely and classy, the pinnacle of skyscraper design in more ways than one.

Owned by the Chrysler Motor Company, William Van Alen's building neatly integrates references to automobile design in its detailing, such as in the flamboyant winged gargoyles that help make the Art Deco-inspired profile (a wider base stepping-in to narrower upper levels) look natural and part of a unified composition.

Even more spectacular is the unique spire, whose curvaceous overlapping metal planes elegantly transform the square plan of the offices below into a slender, soaring vertical peak. Interspersed with the metal plates are a series of triangular windows.

Empire State Building

This is a building of contradictions. Though built in the midst of the Great Depression, it is a symbol of great confidence and excitement. Completed in 1931, it usurped the Chrysler as the world's tallest building, a distinction it held for more than 40 years. Its stepped profile and Art Deco styling are instantly recognizable and have been a powerful icon for New York ever since. The views from the top are spectacular (see opposite).

In spite of its iconic status the tower is very plain when viewed close up. Planned with economy and simplicity in mind, Shreve, Lamb & Harmon's stripped-back design was erected at quite staggering speed by exploiting the advantages of repetition in construction. The framework went up at the rate of a story per day.

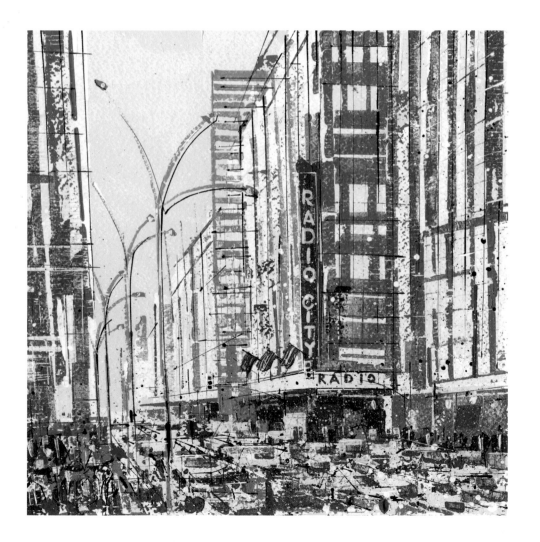

Radio City, Rockefeller Center

From 1932 to 1940 the oil tycoon and philanthropist John D Rockefeller built a complex whose mix of different uses gave rise to a miniature city-within-a-city. The Rockefeller Center provided employment to thousands of construction workers and artists, and the completed buildings attracted high-profile tenants and became a focal point for the entertainment industry. The classy Art Deco buildings emerged, gleaming from a formerly run-down part of New York and an even more depressing economic context.

It was a triumph of organization and workmanship to develop 22 acres and 14 buildings, including a 70-story tower, in such a short time. Amongst its occupants on Sixth Avenue is Radio City. It was conceived as a unique theater offering high-quality, affordable entertainment in a sophisticated interior that avoided glitz or excess.

Lever House

Towards the end of the nineteenth century, the first tall buildings to utilize the new technology offered by steel, iron, glass and concrete still had many decorative qualities. It was only later in the middle of the twentieth century that design philosophy changed to only incorporate into a building what is functionally necessary. Louis Sullivan's famous axiom of "form follows function" became the guideline for the Modernist era.

Built in 1952 and designed by Skidmore, Owings & Merrill, Lever House expresses simply a grid of glazing mullions and transoms holding in place windows and glass spandrel panels. It all has a fresh green-blue tint, as if to express the company's purpose of soap manufacture.

The clean simplicity of the rectangular vertical tower is echoed by a horizontal podium, raised on piloti to create a paved forecourt and a central planted courtyard.

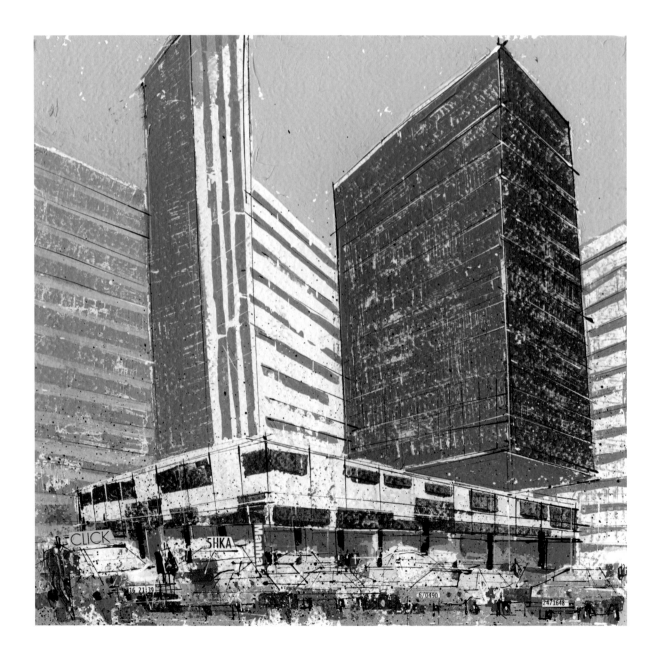

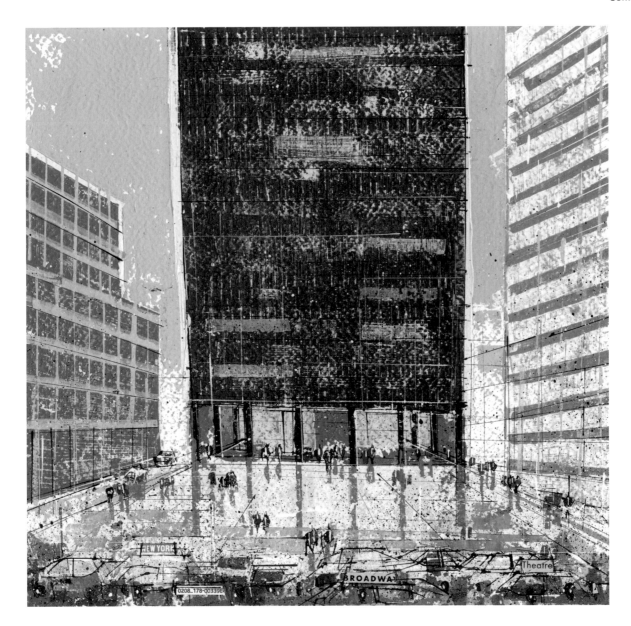

Seagram Building

Almost directly opposite Lever House on Park Avenue, but arriving a few years later in 1958, the Seagram Building by Mies van der Rohe adopts the same philosophy with a more refined solution, offering greater sophistication in detailing, proportion and composition.

The building is set back from the street, creating a public space from which it can be appreciated. Five bays wide and three deep, extruded bronze mullions give the building a vertical emphasis; solid panels express the floor zones with dark tinted glazing in between.

While the earliest New York skyscrapers often gave emphasis to their corners—with columns, pinnacles, bay windows, gargoyles and other paraphernalia—Mies gave the Seagram the exact opposite. The corners recess into the building rather than projecting forward, allowing the facades to read independently as simple separate planes.

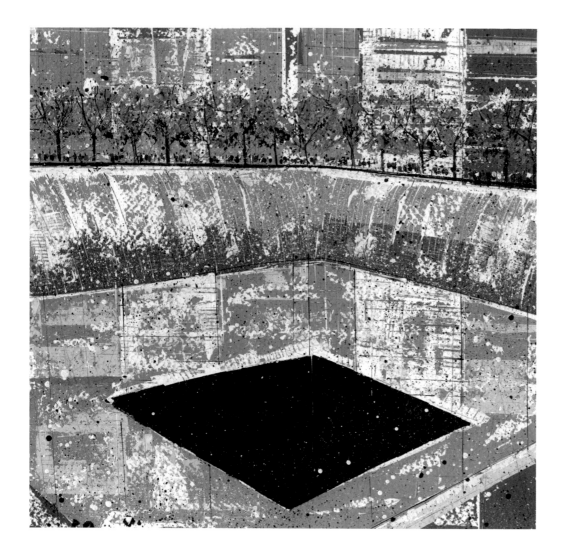

World Trade Center

The tragic events of 9/11 are commemorated with two vast memorials on the footprints of the former Twin Towers. Where once skyscrapers thrust skywards, now there is the antithesis: apparently bottomless caverns plunge into the ground with veils of water flowing eternally down into them from all four sides.

New York has defiantly replaced the Twin Towers with new adjacent buildings, but sadly these glass towers have not matched the hypnotic quality of the reflecting pools that they surround. The best of the group is One World Trade Center, the Freedom Tower, which stands at a symbolic 1,776 feet high, and has 102 floors. An observation deck is located at the same height as the original towers. Its form,

which went through countless design iterations, is simple but eye-catching; its angled shape reflects the light in a multitude of ways.

The 9/11 Memorial Museum is both overwhelming for its personal and emotional content and impressive for the sheer quantity of information it contains. Among the exhibits is a sample of the 'composite' rubble that was formed through the fusion of metal, plastic, glass, concrete and dust in the heat of the blaze that followed the atrocity.

Greene Street, SoHo-Cast Iron Historic District

Cast iron facades became popular in the 1870s when decorative detailing was prefabricated in molds and mass-produced for economic reasons. So many were built in one area that it has become known as the SoHo-Cast Iron Historic District.

The cobbled Greene Street is the perfect setting for these buildings. In a way, although ornate in their neoclassical detailing, they are expressive of their construction, anticipating the Modern Movement. With lofty ceilings and attic spaces, they are now ideal for conversion into art studios, workshops, boutiques, galleries and restaurants.

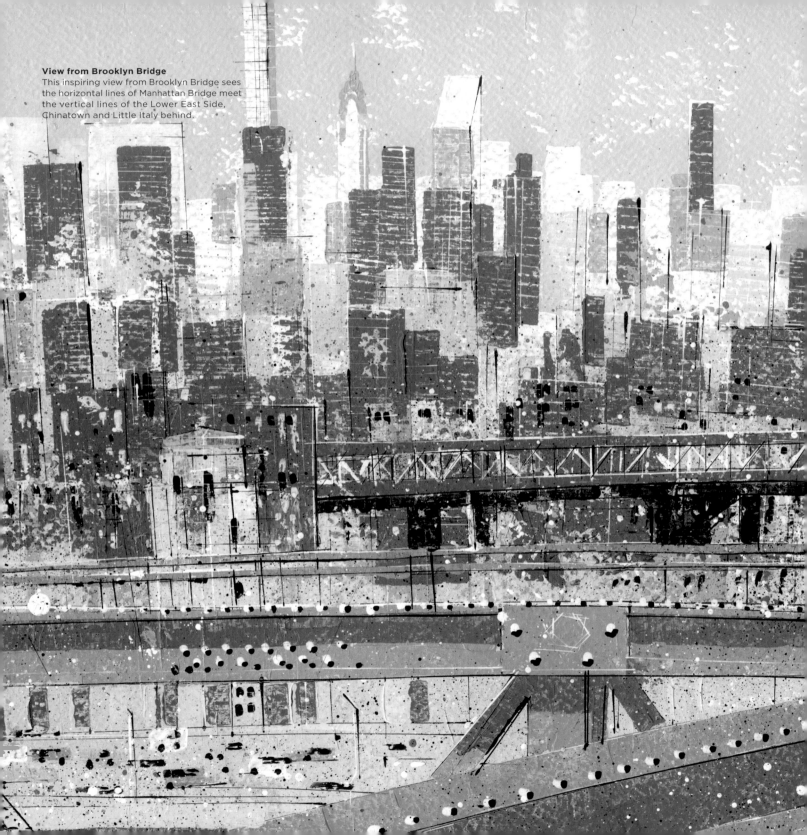

View from Brooklyn Bridge
This inspiring view from Brooklyn Bridge sees the horizontal lines of Manhattan Bridge meet the vertical lines of the Lower East Side, Chinatown and Little Italy behind.

KNOWLEDGE AND CULTURE

The purpose of a great city evolves. New York has practical, functional origins with its great harbor bringing trade, industry and commerce. These have generated income and growth, and the need for intense use of the land available. Today that success, signified by those great skyscrapers, has become a magnet for tourism, and the thirst for experiences and knowledge that comes with that.

At the same time, New York's rapid expansion has attracted diverse immigrants and visitors, and that has led to its wide-ranging culture: music, dance, theater, visual arts, television and film. This in turn has created a demand for venues for rehearsal and performance, exhibitions and displays. These are often grouped together—for example, the largest theaters are clustered around Broadway and Times Square. Carnegie Hall is one of the finest for its opulence and acoustic excellence, while the Lyceum and the New Amsterdam are the oldest Broadway theaters.

Museums and galleries are more dispersed, although there is a gathering along Museum Mile on Fifth Avenue. Some are iconic design statements in their own right; others provide a more neutral backdrop for the display of art.

The city's status as this world-recognized cultural center has directly resulted from its commercial achievement, because with that success came the finances for both public and private collections to accumulate outstanding treasures. Some of the world's greatest artworks now reside here. Consider the collection of Henry Clay Frick: he was a wealthy industrialist, who built a mansion on the eastern side of Central Park, in which he assembled fine art by Turner, Vermeer, Rembrandt, Holbein and many others. The house and its wonderful contents were left in his will to the nation.

Similarly, the privately owned Morgan Library and Museum were gifted to the city of New York in 1924. The library was designed in 1906 by Charles McKim for Pierpont Morgan. Built to resemble a grand Italian palazzo in the Renaissance style, it is beautifully proportioned and highly decorative. In 2006 it was expanded through a series of extensions and interventions by Renzo Piano. His work is beautifully judged, exhibiting fine craftsmanship and attention to detail, but with an elegant approach that minimizes the impact of additions to the historic original.

One of the city's top academic institutions is New York University, collected around Washington Square Park. In Upper Manhattan, Columbia University has the sense of being a defined campus, set on Morningside Heights. It was founded in 1754, making it the oldest university in New York. It prides itself on its publicly accessible open spaces, lined with trees and transparent buildings that encourage the sharing of ideas and social interaction.

New York City has provided a romantic backdrop to countless films and television shows, from Audrey Hepburn gazing into Tiffany's windows on Fifth Avenue in 1961's *Breakfast at Tiffany's* to the much-loved TV shows *Friends* and *Sex and the City*.

128 Pierrepont Street, for the Brooklyn Historical Society

128 Pierrepont Street in Brooklyn was designed in 1881 by George B Post for the Long Island Historical Society (which changed its name to the Brooklyn Historical Society in 1985). It was at around the same time that Sir Alfred Waterhouse was making similarly decorative buildings, such as Manchester Town Hall, in England. Both architects looked to exploit mass-produced terracotta as an economic way of adding richness and texture to their brick facades.

The stained glass windows and carved stone figures of some of history's greatest creative minds—Shakespeare, Beethoven, Gutenberg and Michelangelo—integrate bespoke artistic detail into the building.

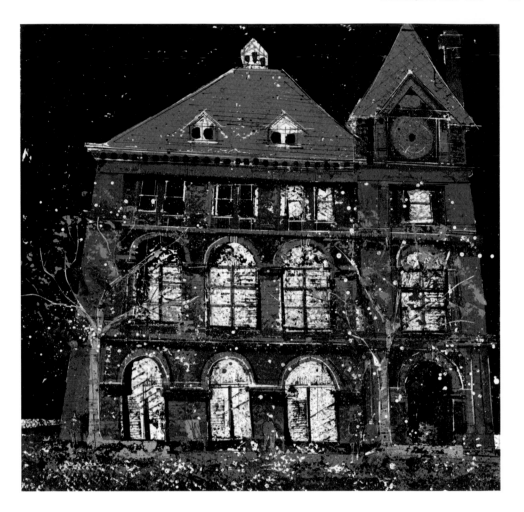

New York Public Library

Classical in form, symmetrically composed and grandiose in expression, the library embodies the style promoted in the late nineteenth century by the École des Beaux-Arts in Paris. Designed by Carrère & Hastings, who won a design competition, it was built in 1911.

The expansive entrance staircase leads up from Fifth Avenue to the entrance portico, creating a place for meeting and gathering. The immensely thick marble walls, refined decorative detailing and high-quality materials were thought to have befitted a major public building like this at the time, although you might wonder how relevant all this is to what a library now needs to offer, in the twenty-first century.

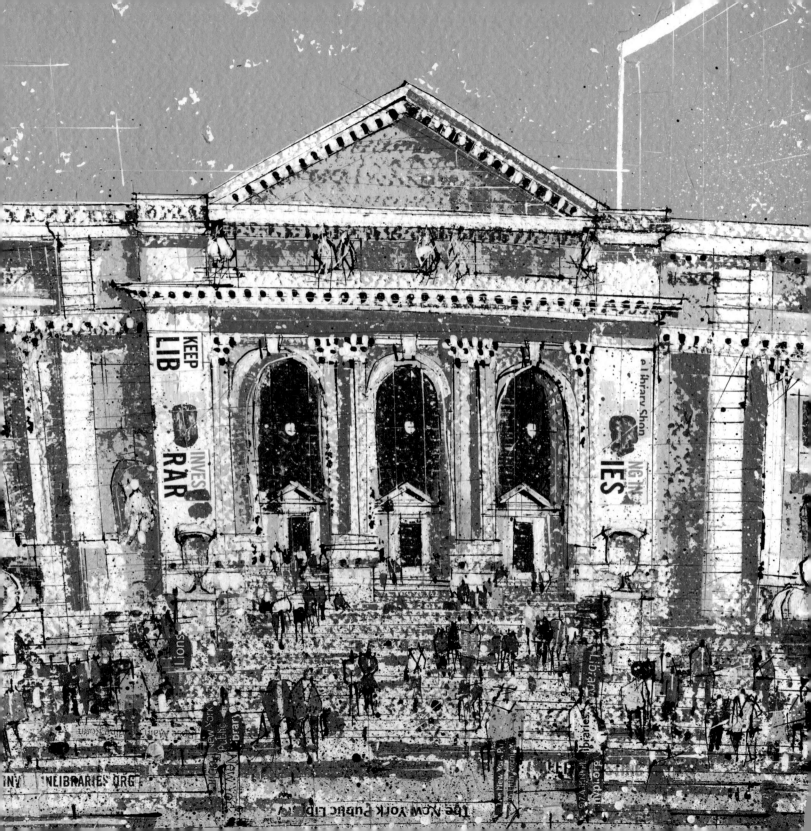

Lyceum Theater

Completed in 1903 to the designs of Herts & Tallant, this is one of the oldest and finest theaters on Broadway. Its extravagant Beaux-Arts facade performs its role of creating a sense of occasion with real élan.

The six huge fluted columns provide gravitas and combine with the brightly lit foyer to create a dramatic facade. The references to Greek architecture and opulent decoration were applied to the theater interior with equal flamboyance.

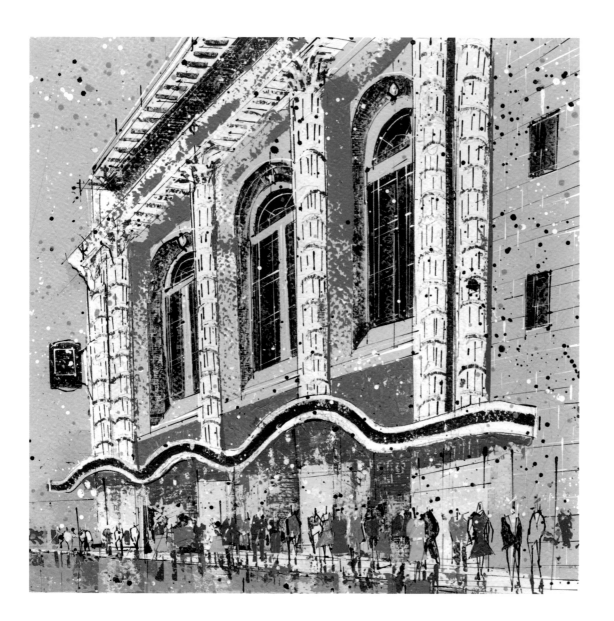

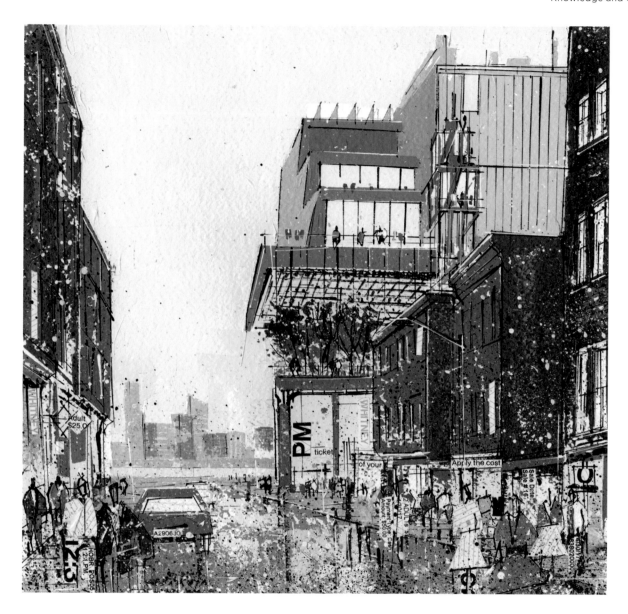

Whitney Museum of American Art

The Whitney Museum of American Art connects the southern terminus of the High Line to views of the Hudson River—a splendid opportunity exploited by Renzo Piano in his design. The first floor is glassy, open and welcoming—which helps to make this connection, and to visually express the cafe, shop and ticket hall.

The top floor is also outward-looking, with another cafe combining with platforms that provide vantage points from which to view the surrounding Meatpacking District, and which are linked together by vertiginous external staircases. The floors in between have blank facades that reflect the vast galleries: they are introverted blank boxes to the outside, but treasure-troves of creativity inside.

Museum of Modern Art (MoMA)
The finest museums, galleries and libraries of the nineteenth century took their inspiration from classical architecture—great municipal expressions of civic pride and wealth—and incorporated sculpture and ornamentation that made them works of art in themselves.

This philosophy changed. Today's approach may still make use of sumptuous materials, but tends also to be about refinement and understatement, and avoids distracting from the works on display.

MoMA was one of the first to embody this change. A new insertion into 53rd Street in 1939 saw starkly modern, horizontal glazing set into an abstract plane of white marble. Designed by Philip Goodwin and Edward Durell Stone, subsequent additions—notably by Philip Johnson and Yoshio Taniguchi—have adhered to the same fundamental idea.

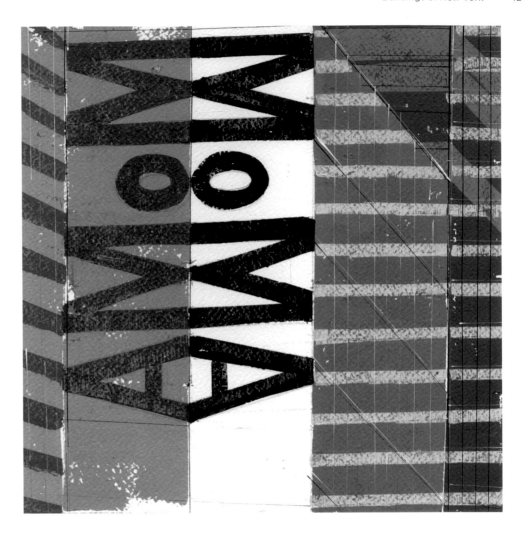

Jefferson Market Courthouse
This is a delightful concoction of Venetian Gothic-inspired forms: a steeply pitched roof, gables, pinnacles, spires and turrets form an ornate skyline above brick elevations with leaded windows.

Its greatest success is that it is still here. It was built in 1877 to provide a police court, a civil court and holding jail for prisoners, but these functions moved elsewhere in 1945. Empty and threatened with demolition, the beloved building was saved by preservationists and now forms part of the New York Public Libraries.

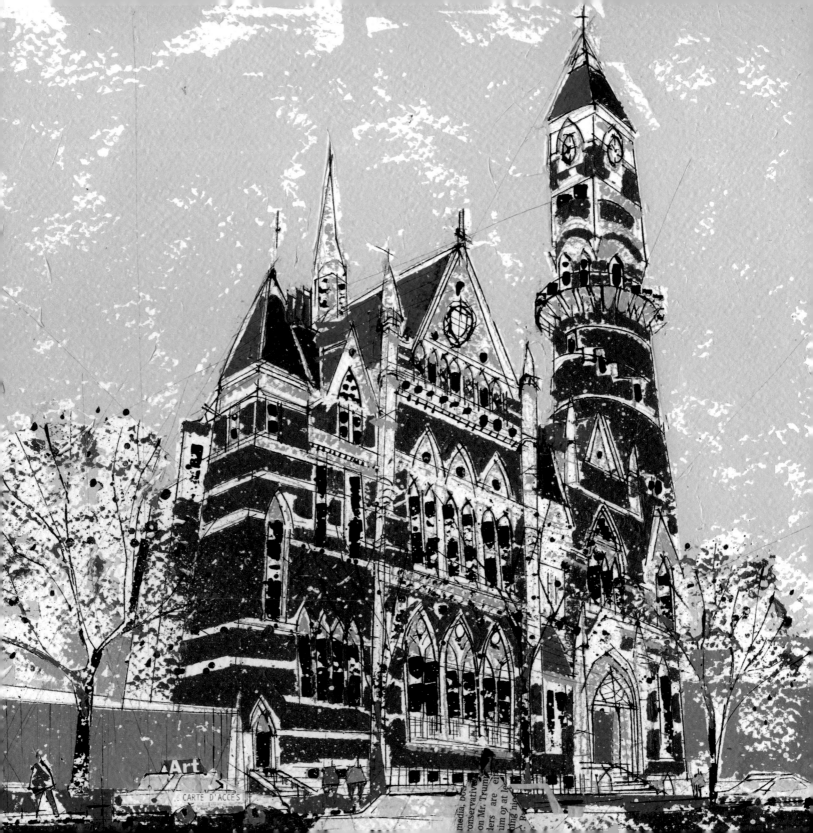

Solomon R Guggenheim Museum
This is one of Frank Lloyd Wright's
most iconic creations, the result
of reconsidering how the public
views art. The solution is brilliant,
allowing the viewer to perambulate
up a gentle, spiraling ramp (some
visitors, as Wright intended, instead
take the elevator to the top and then
walk down the ramp). The artwork is
displayed in bays to one side of the
spiral, which is subdivided by the
structural support fins.

The project to build the museum
had to withstand delays and fierce
criticism from artists—as well as the
deaths of first Guggenheim and then
the architect himself.

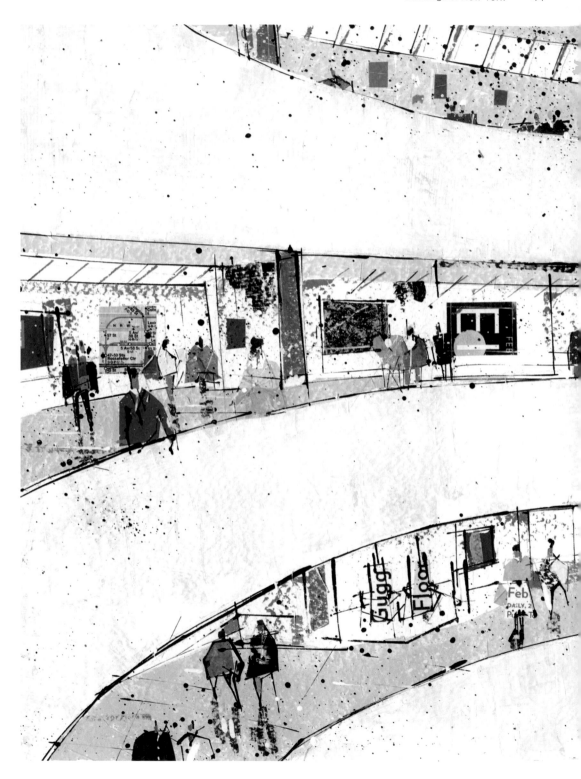

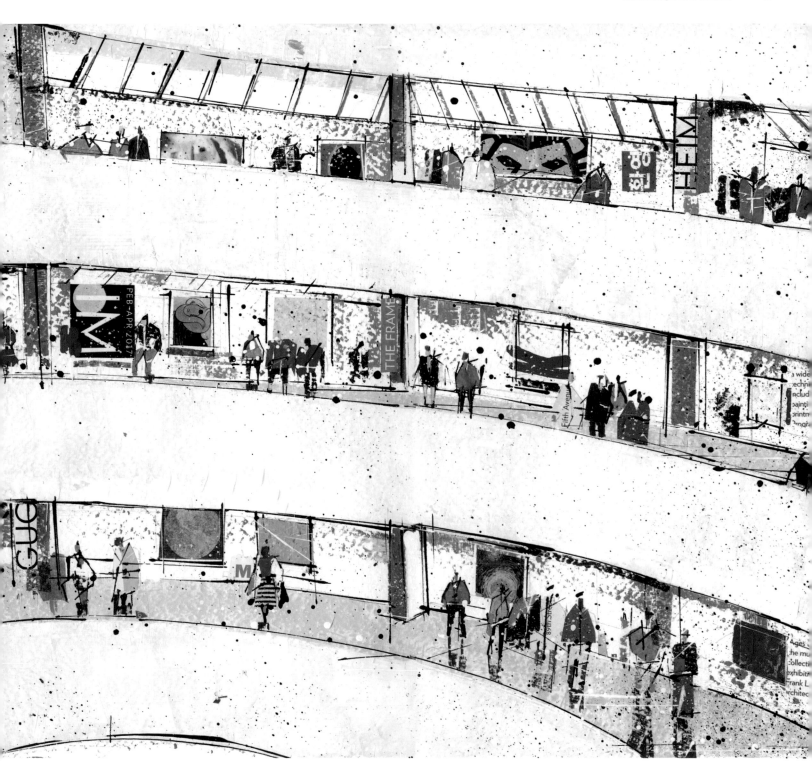

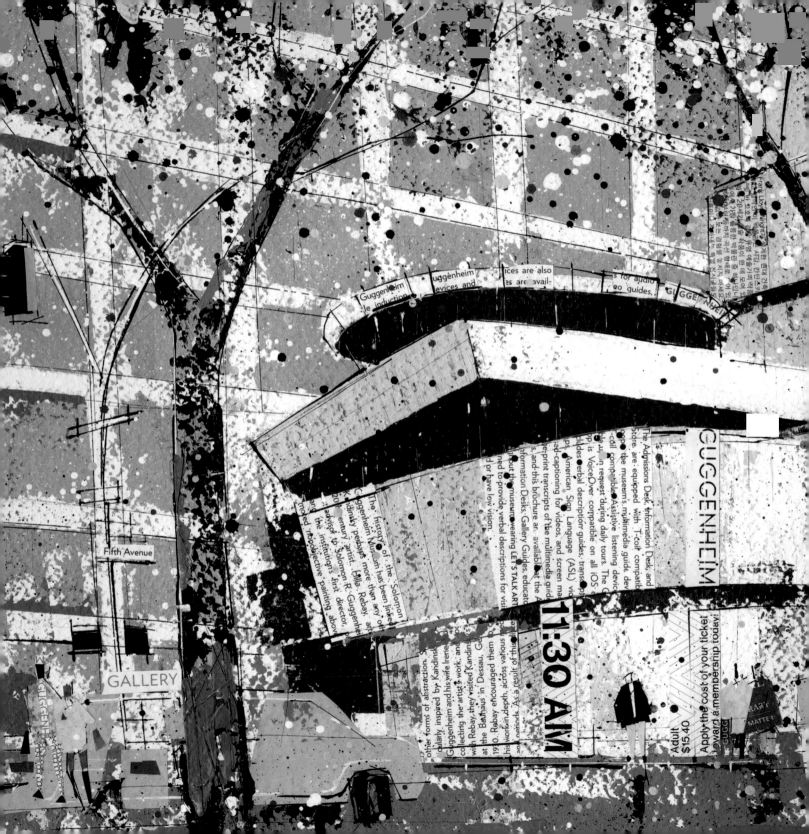

GALLERY

Fifth Avenue

GUGGENHEIM

11:30 AM

Adult
$15.40

Apply the cost of your ticket
toward a membership today!

Guggenheim
le induction uggenheim
 evices and ices are also
 es are avail- s for audio
 eo guides. GUGGENHEIM

The Admissions Desk and
tore, are equipped with T-coil compatible
op the museum's multimedia guide dev
-coil compatible Assistive listening devic
ou request during daily tours. The G
pp is VoiceOver compatible on all iOS d
cludes verbal description guides, transc
American Sign Language (ASL) vid
ad-captioning for videos, and screen ma
print transcripts of the multimedia guide
, and this brochure are available at the A
nformation Desks, Gallery Guides, educato
out the museum wearing LET'S TALK ART
d to provide verbal descriptions for visi
d or have low vision.

The history of the Solomon
Guggenheim Museum has been linked
k)ggenheim perhaps more than any ot
dinsky, artist Hilla Rebay, an
collecting the artist's work, and
with Rebay, they visited Kandin
20 century artist.
advisor to Solomon R. Guggenhei
at the Bauhaus in Dessau, Ge
1910. Rebay encouraged them
and the institution's first director,
noted nonobjective painting, above
his work in depth, across various
periods. As a result of his
other forms of abstraction. S
olarly inspired by Kandinsk
Guggenheim and his wife Irene

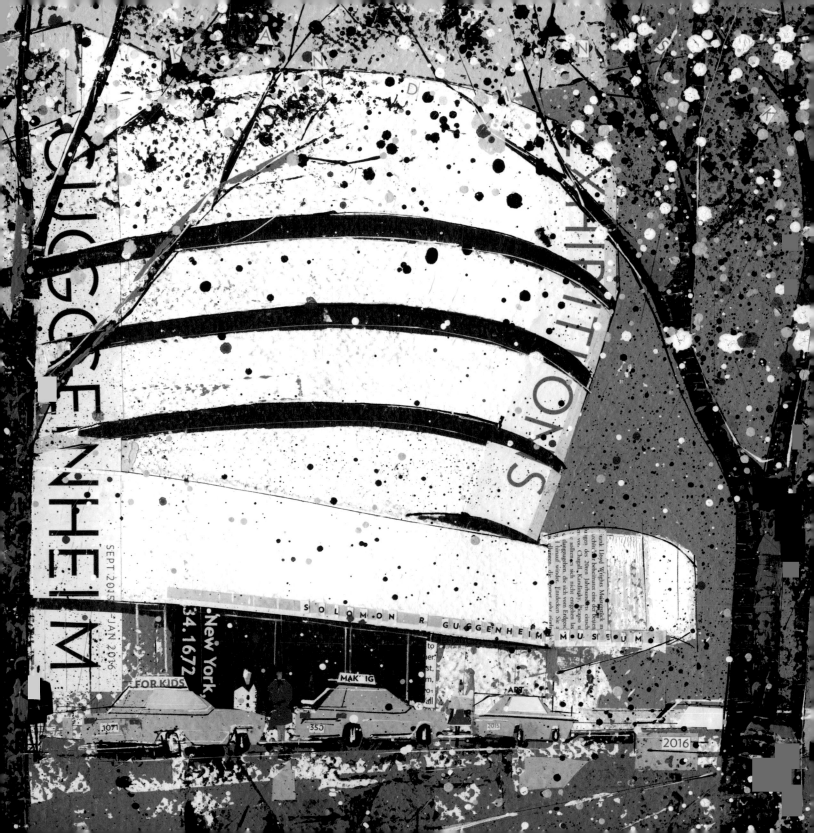

RELIGION

The overriding character and distinctive skyline of New York are generated by its commercial buildings, but within its busy urban framework the city possesses many valuable religious buildings that act as more reflective spaces. This multicultural and multifaith city sees churches, chapels and cathedrals complemented by synagogues, temples and mosques. Because they are unique, and strikingly different to the surrounding architecture, these buildings have visual and emotional impact that belies their comparatively diminutive scale.

The buildings are important, but so too are the external spaces that surround them. The churchyards offer tranquil settings off busy streets, providing peaceful places for quiet contemplation. Often they are surrounded by a canopy of trees that creates natural planting in relief to the hard urban environment, and a sense of contrast through light and shade.

New York does not possess a focal point for a particular religion in the way that Rome's St Peter's Basilica, for example, is home to Catholicism, or Mecca houses the Great Mosque. It cannot offer ancient history, as provided by the Parthenon in Athens, nor does it have visually striking landmarks, such as the Golden Temple in Amritsar or St Basil's Cathedral in Moscow.

What it does provide are buildings that have been important in its own relatively short history: churches that once stood proudly as the tallest structures in New York; buildings that were inspired by great architects and that have played important roles in the history of the capital; and some of the oldest buildings to have been in continuous public use in all of Manhattan.

Many of the churches have embodied faith in the sense of a belief in the future of the city. Some were built in what was then nearly wilderness, well beyond the edge of the built-up city—but now they stand in testament to the confidence that in time the tide of development would reach up to and surpass them.

As the city has grown and changed, so too have religious buildings needed to accommodate change themselves. In the case of Central Synagogue—designed by Henry Fernbach, a Jewish architect born in Prussia—a major fire in 1998 was a potentially transformative event. Built in brownstone on a basilica plan with Moorish-revival decoration, the restoration has been faithful to the original. The facade to Lexington Avenue features two octagonal towers topped by green copper, onion-shaped domes. The Tribeca Synagogue, by contrast, is strikingly modern with a curvaceous frontage expressing a top-lit sanctuary; a building design generated by the cross-section. As its surrounding community has changed, the name of the Synagogue has evolved to appeal to different congregations. Starting as the Civic Center Synagogue, it then became the Synagogue for the Arts, before assuming its current name. Meanwhile, a corner site on Canal Street, marking the entrance to Chinatown, was once the home of a seedy cinema. In 1996 it was converted to accommodate the Mahayana Buddhist temple. The interior features a very large, 16-foot, golden statue of the Buddha.

The churches and chapels that once created the skyline have since been dwarfed by surrounding commercial architecture. In spite of this they still assert authority and status—no longer through scale, but on account of their qualities of proportion, material and detail.

While that skyscraper-punctuated skyline is famous worldwide, in one or two cases the scale of the cathedrals is also of global importance, representing enormous and ambitious undertakings that can provide a common purpose for successive generations.

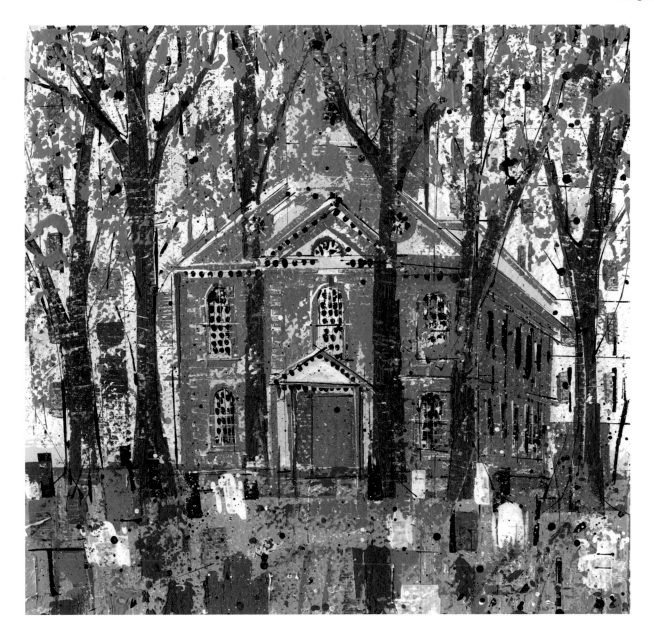

St Paul's Chapel

The oldest church on the island of Manhattan, this was built in 1766 and so predates the American Revolution. Georgian Classical Revival in style, it was surrounded by farmland when it was built. The addition of a steeple in 1794 made this the tallest structure in the city.

Its architect Thomas McBean had excellent credentials: he was the pupil of James Gibbs, who was the disciple of Sir Christopher Wren. The chapel was clearly influenced by Gibbs' best composition, St Martin-in-the-Fields Church in London's Trafalgar Square.

After George Washington took the oath of office on April 30, 1789 and became the first President of the United States, he came from Federal Hall to worship here.

Although located close to the Twin Towers, it remarkably avoided damage in 9/11, and during the rescue operations St Paul's became a refuge, providing food, shelter and counseling.

St Patrick's Cathedral

Construction of St Patrick's Cathedral began in 1858, lasting 21 years. Inspired by the design of a French High Gothic cathedral, St Patrick's was built some way to the north of the extent of built-up Manhattan as it existed in the nineteenth century. The Cathedral's characteristic soaring verticality would have dominated its original setting.

But, inexorably, New York grew to reach and then engulf the once-remote Cathedral, which is now surrounded by offices of far greater height. These remain somehow peripheral though, because the Cathedral still exerts a presence through the quality of its decoration, detail and materials.

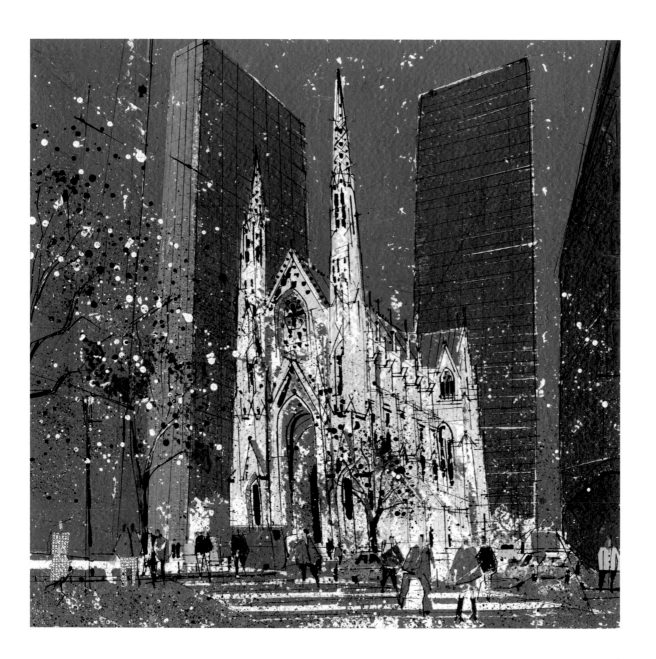

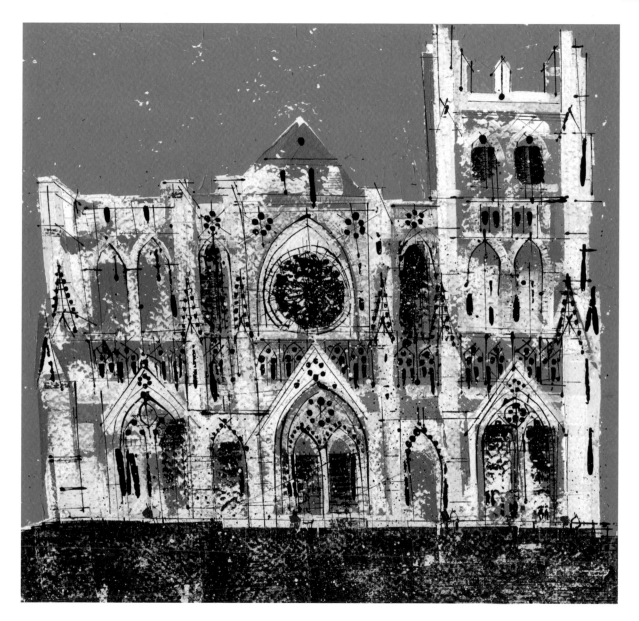

Cathedral of St John the Divine

Begun in 1892 on a prominent raised site at Morningside Heights, and still nowhere near finished, this cathedral claims to be the largest in the world (St Peter's Basilica in Rome is larger, but not a cathedral). It is a reminder that in medieval times it was normal for cathedrals to take centuries to construct.

I actually like the incomplete asymmetry of the Romanesque/Byzantine main facade onto Amsterdam Avenue with its bell tower—begun in 1982—still incomplete. The composition pivots around the huge circular rose window with projecting porches below.

The design was radically altered after a large Romanesque central dome was completed in 1909 with the nave and apse changed to a neo-Gothic style.

Trinity Church

Now surrounded by skyscrapers, this was once the tallest building in New York. This is a very wealthy church, which owns several acres of real estate in Manhattan.

The churchyard is a nice little space, but the Church's greatest contribution to the cityscape is the way it closes the vista, framed by tall buildings on either side from Wall Street to Broadway.

Built in the English Perpendicular Gothic style, its interior is cool and white, and exudes a refined simplicity.

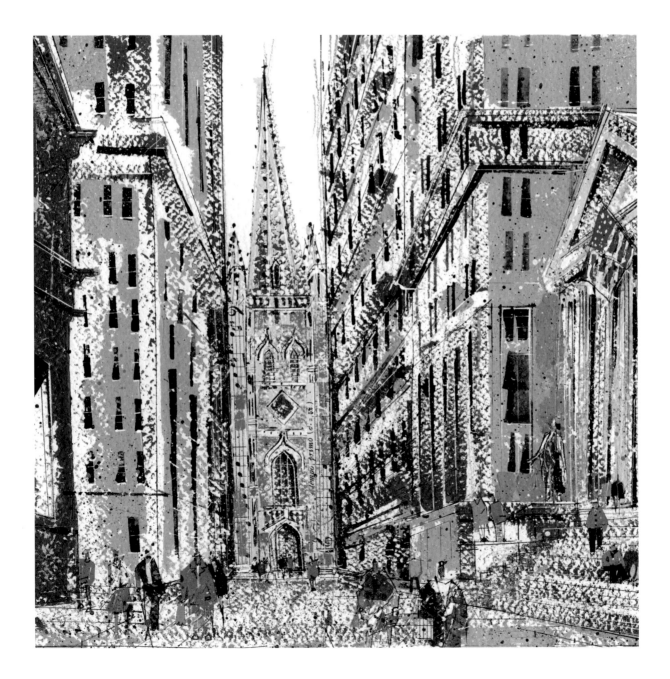

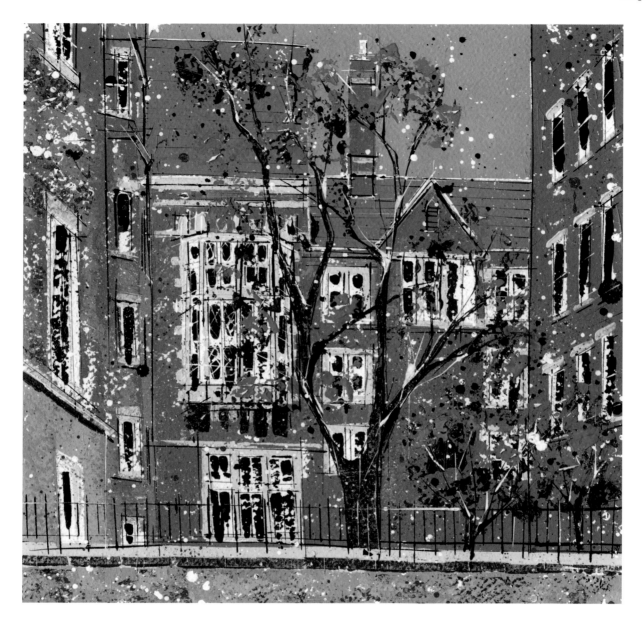

General Theological Seminary

Set in the center of Chelsea, the seminary's neo-Gothic buildings are formally arranged around delightfully tranquil gardens to create what is known as the Close: a term derived from the setting of English cathedrals. The mature trees cast dappled shade over the buildings, and the grounds help to create the peaceful setting appropriate for a studying community.

Its foundation dates back to 1817, but it was under Dean Hoffman that rapid growth took place; its development was modeled on the medieval college courtyards of Oxford and Cambridge. To glimpse the quadrangles through decorative railings from the adjoining streets is to witness a highly unusual arrangement in New York.

LIVING

Cities are like living organisms: constantly growing, changing and regenerating themselves. As land values have soared, city blocks that were once occupied by homes have been redeveloped for offices and other commercial uses of greater value. Conversely, buildings once used for industry or storage have become the trendiest places to live. An asset's value constantly changes, and residential uses currently achieve the greatest return on investment—meaning residential skyscrapers are proliferating.

Much of New York's earliest housing on the southern tip of Manhattan has been redeveloped over time. Fortunately, you can still get a sense of the bygone age: the Old Merchant's House preserves the dwelling of a wealthy early-nineteenth-century merchant, while the Frick Museum provides an idea of an opulent mansion built on Fifth Avenue. By contrast, the Tenement Museum offers a glimpse into a building used as a home and workplace, packed with multiple inhabitants.

Immigrants formed their own communities, bringing national identities to different neighborhoods. With chronic overcrowding tenements became like slums, and, as soon as they acquired sufficient wealth to do so, people moved out to places like Brooklyn, becoming the world's first commuters. They traveled to Wall Street, which became exclusively a business district—a financial zone in which no one actually lived. Crucial to this separation of home from work was a transportation system.

At the end of the nineteenth century the disparity between rich and poor was acute. Two miles of sumptuous mansions along Fifth Avenue contrasted starkly with half a million people living in immigrant slums on the Lower East Side. Living and working conditions improved with new laws introduced following a fire at the Triangle Shirtwaist Company in 1911, which killed 146 factory workers.

Land values were high even in the nineteenth century, so real estate developers made intense use of their sites, constructing terraced properties in popular revivalist styles. The brownstone became a typical house type, with narrow frontages and deep floor plates maximizing the number of houses per terrace.

Responding to the same commercial pressure, apartment buildings became popular, and further intensified the density of residential accommodation. The Dakota provided 65 apartments when completed in 1884. Its architect, Henry J Hardenbergh, subsequently designed a similar enormous cube of a building, again facing Central Park: the Plaza Hotel. Reflecting the growing need to accommodate tourists visiting the city for pleasure, the architectural expression there is opulent.

Buildings like the Dakota and the Plaza Hotel emphasize the city block. By contrast, Greenwich has retained a more informal street pattern, bringing a bohemian character and avoiding the large-scale commercial redevelopment that is more suited to rectilinear sites. As values continue to soar, areas once deemed less 'desirable', such as Harlem and the Bronx to the north of Manhattan, and Brooklyn to the south, have become gentrified.

Closer to the center, the market for luxury apartments is booming, which has meant an upsurge in new skyscrapers. There are tight guidelines for the size, height and shape of these blocks. While that may lead to an acceptable appearance, social integration is another matter entirely. Towers by their nature are separate from one another, and their astronomical land values and high construction costs mean that they are only for the very wealthy, leading to concerns that the essential social and physical character of the city is being eroded.

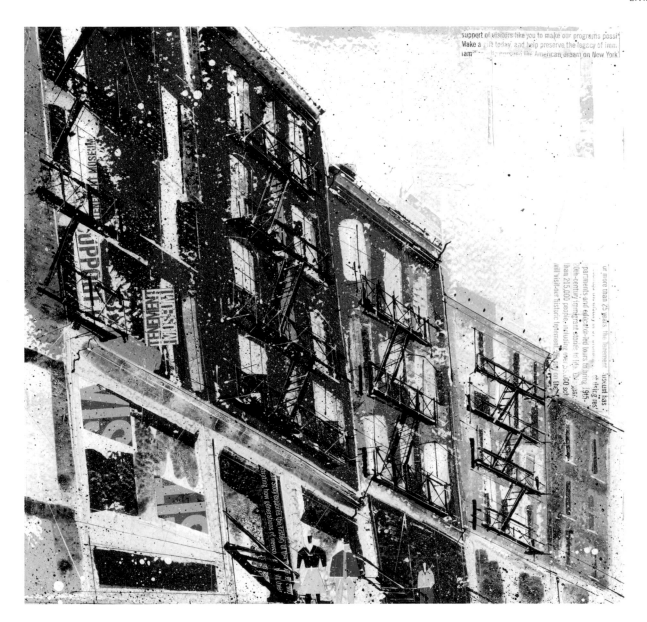

Lower East Side Tenements

Towards the end of the nineteenth century, high immigration levels caused the population of the Lower East Side to grow rapidly from 1 million to 3.5 million. Tenement buildings provided high-density living: with a minimum of four or five people in every apartment, four apartments per level and buildings on four or five stories, a typical tenement would house an excess of 100 people.

The flat plan was three rooms deep, the inner rooms having internal windows to borrow light from the front room. With many tenants unable to read or write, tailoring was a common occupation, so homes doubled up as workhouses and saved entrepreneurs the cost of providing and running a factory.

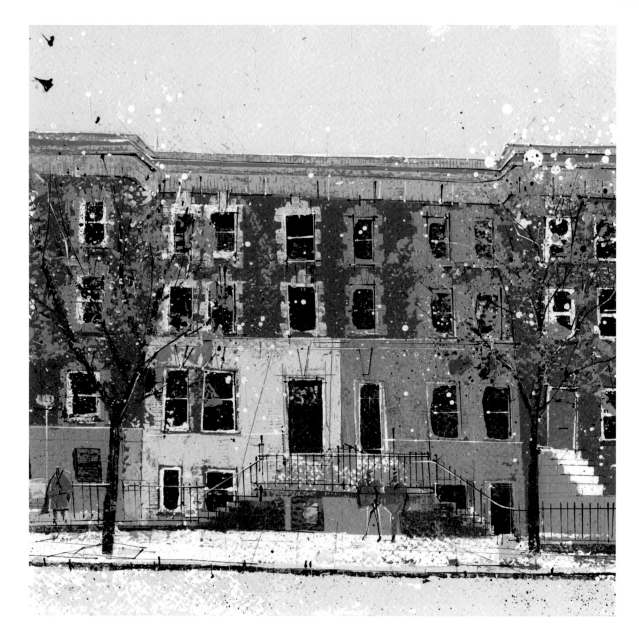

Strivers' Row

In the 1890s Harlem terraces were built of similar materials and styles—Georgian here, Italian Renaissance influences there—to create rows of houses and apartments. By the 1920s, Harlem had become a focal point for African Americans. Following a period of economic decline, the fine houses remained sought after by those who aspired to improve their status—doctors, lawyers and other professionals.

The floor plan of a typical house is very efficient with little space lost to circulation. There is a full-width room at the front and another at the back. The staircase rises in the middle with the landing extra-wide to create a usable space—as a breakfast area, library, or simply for access to small bathrooms or a laundry room.

Today these well-built houses, set in quiet roads lined with large trees, are attracting outside investors wanting to buy up real estate—they are striving in their own way, but not necessarily emerging from the local neighborhood.

Gracie Mansion

Designed in the Federal style and dating back to 1799, this wooden country house was built by Archibald Gracie, a wealthy merchant. At the time it was five miles north of the city, and with its verandas and lawns overlooking the East River it would have been an idyllic rural spot.

As it passed through successive owners, it was appropriated to the city in 1896 in lieu of a tax bill. After a period as the Museum of the City of New York, in 1942 it became the official residence of the Mayor of New York.

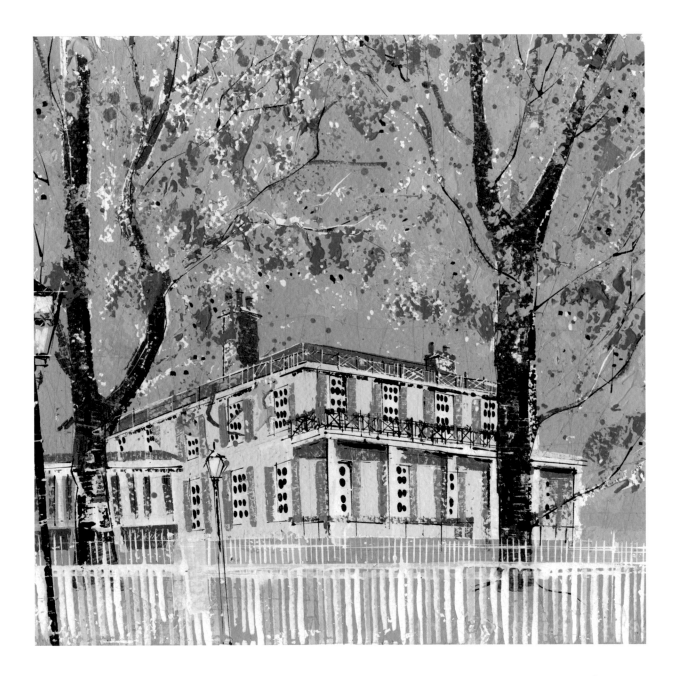

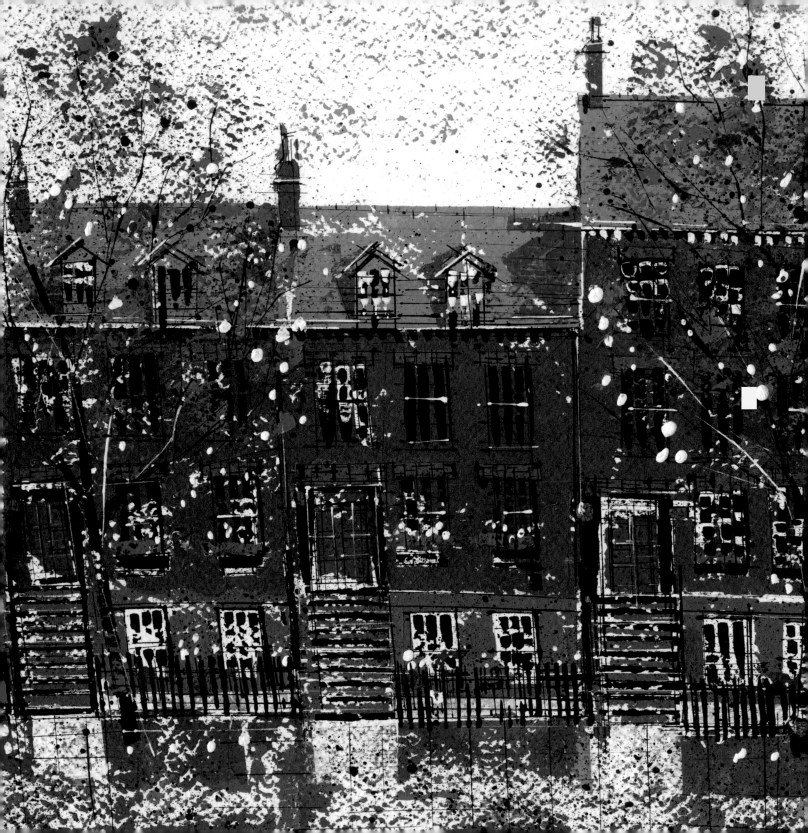

155–159 Willow Street

This group of three brownstone houses was designed in the Federal style and is one of the best examples of the period. 155 and 157 retain their original slim, tall dormers, while 159 has been spoiled through the loss of the original roof and the addition of an extra story.

The term "brownstone" reflects not just the color of the facades but has come to mean a New York building type. These were houses for occupation by a single family, typically including a basement for servants: four stories above; a light well at the front, protected by iron railings; steps up to a first floor entrance above street level; and decorative detailing such as cornicing and ornate door surrounds.

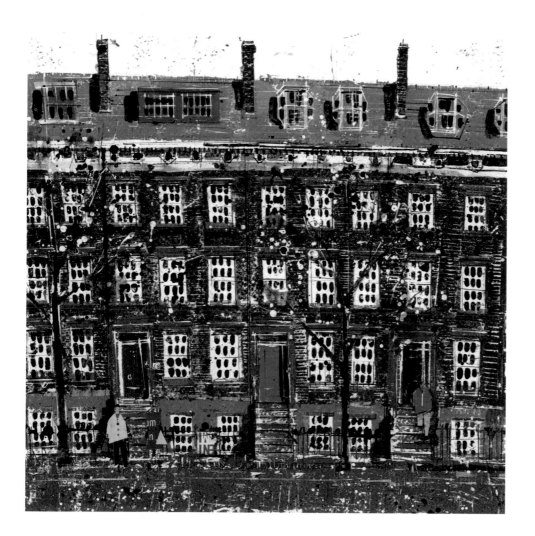

Cushman Row, 406–18 West 20th Street

This terrace, Cushman Row, is in a Greek Revival style and was built in 1840 by the real estate developer Don Alonzo Cushman. My favorite aspect of it is the use of red brick with thin mortar joints, requiring bricks of minimal variation in size and immaculate craftsmanship.

A plaque on the building proclaims it to be "one of the finest examples of Greek Revival style of architecture in New York". It then goes on to point out that the row of houses retains most of its handsome original detailing—all of which is true.

Grove Court, Grove Street
Some of the best parts of New York
you stumble across by chance. This
picturesque little private courtyard is
just off Grove Street between numbers
10 and 12.

I mentioned earlier how cities
change, and this former backwater,
for instance, has been transformed.
When built in 1854, this group of six
townhouses became known as "Mixed
Ale Alley", referring to the cheap
drink consumed by its poor residents.
Today the homes are highly desirable
for being centrally located yet in a
peaceful, private enclave.

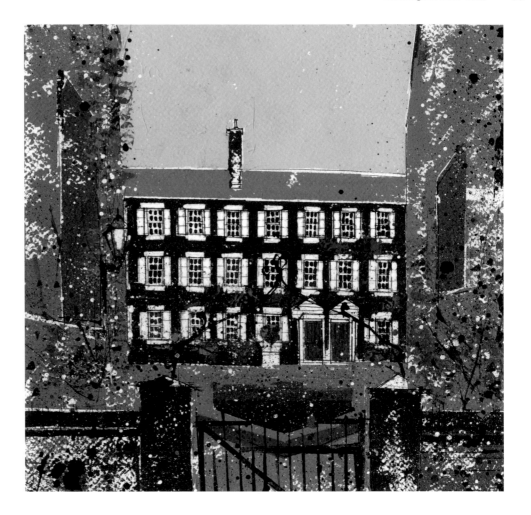

Grove Street, Greenwich
This is unusual in Manhattan. Instead of an
endless view into infinity, the vista is closed by
the curve of the street—a remnant of historic
real estate boundaries. With mature trees
overhanging the road and individually colored
houses, the street has a calm, domestic character.

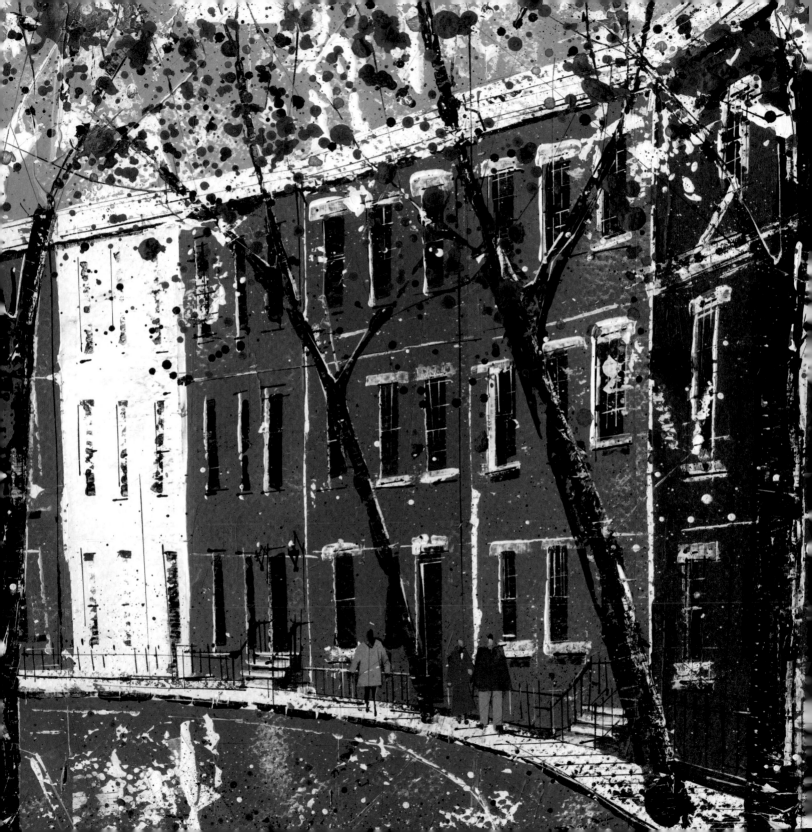

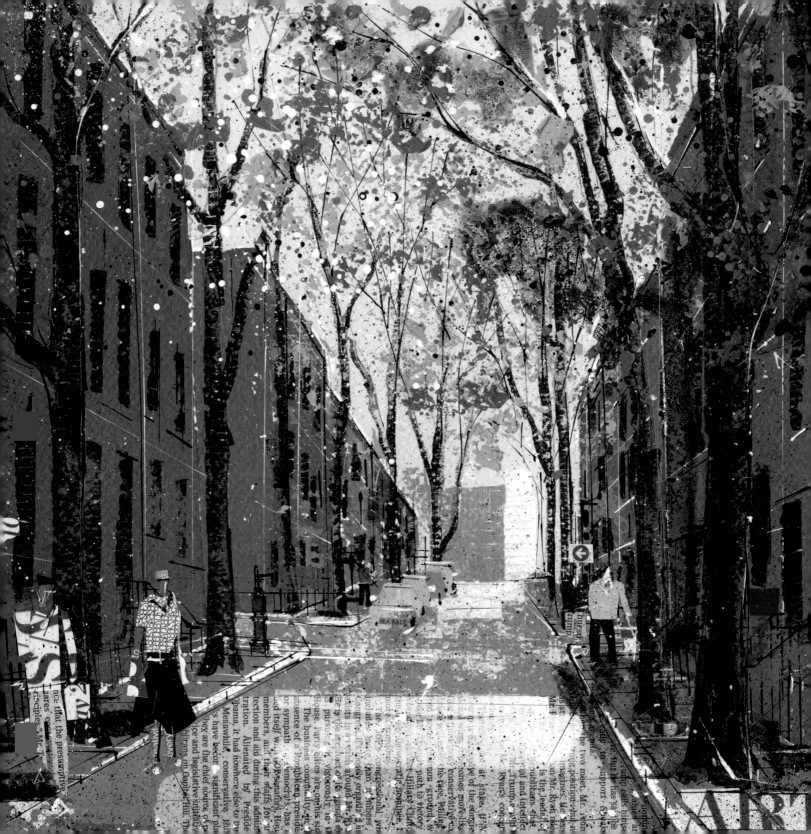

Cranberry Street, Brooklyn Heights
Just across the East River and only three miles or so from Wall Street lies a tranquil neighborhood from another age: Brooklyn Heights. Cranberry Street is one of its most desirable parts, climbing gently away from the river.

Old Merchant's House Museum
Built in 1832 in what was then a suburb, this house on Fourth Street and its contents have remained largely unchanged, acting as a unique record of domestic arrangements from the first half of the nineteenth century. The exterior conceals the scale of the interior, although the railings and entrance doorway betray the wealth of the owner. This is still more apparent internally, through the quality of material and craftsmanship, as seen in the balustrade and decorative plasterwork.

The floor plans of the front and back parlors on the main entrance level are repeated on two of the floors above as the master bedrooms. They are separated by closets and storage, and a connecting passage. The spacious attic—barely apparent from the street—contains the servants' accommodation, while the basement houses the kitchen.

The rear garden, enclosed by high walls, reminds me of the private courtyard garden of Charles Dickens' house, which is a similar oasis, set within the center of London.

Sixth Avenue, Brooklyn
New York City's oldest surviving building, a one-room farmhouse built in 1652, is in Brooklyn. The timber and cladding tradition continued for centuries: while Brooklyn has lots of brick and brownstone dwellings, its many nineteenth-century wooden row houses lend the townscape some contrasting individualism.

In such a dense urban environment wooden houses are a fire hazard, and so insurance companies extended fire codes into Brooklyn in the late nineteenth century to preclude them. Timber-framed buildings are fragile in many ways, but with good maintenance can last indefinitely.

Dakota
Photos of this apartment building when it was first built show it standing in splendid isolation. As the city has expanded northwards, there has always been the confidence that its growth would be inexorable—that a new development beyond the urban edge would never be left isolated.

When the Dakota was constructed, the fashionable inspiration was fairytale palaces and castles, here represented by romantic turrets and gables. The contrast is stark with today's demand for simplicity, in which there is no expression of the individual residential unit, and a building's personality is instead subsumed into a single, large, iconic statement.

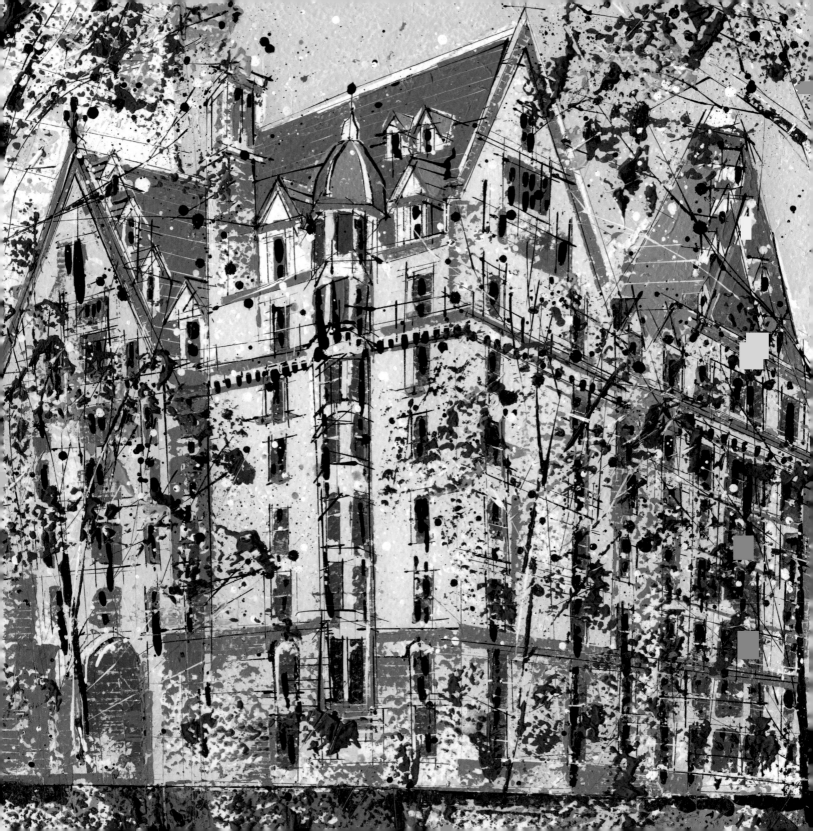

PLACE

New York's essential character can be traced back to the previously mentioned 1811 Commissioners' Plan (or, to give it its full title, the "Remarks of the Commissioners for Laying Out Streets and Roads in the City of New York, Under the Act of April 3, 1807"). The clue is in its title—thoroughfares were prioritized at the expense of open spaces. This was justified on the grounds that "if the city of New York was destined to stand on the side of a small stream such as the Seine or the Thames, a great number of ample places might be needful". The view was that the long arms of sea that embrace Manhattan would provide more than enough fresh air and open prospect, avoiding the need to make provision for this within the street layouts.

So many great cities have distinctive external areas, formal and informal urban squares. As a result of the conscious decision that these were not necessary, Manhattan is dominated by its streets: great axial routes and canyon-like spaces full of movement, noise and color. The buildings, though individually vast in scale, combine to form a backdrop to the life of the city—the endless engrossing spectacle of people going about their everyday lives.

City squares are destinations: places to stop for coffee, to be static. By contrast, streets provide the conduit for motion, generating an endless tide of movement. The streets of New York, one after another after another, give a pace and a particular character. The Commissioners also considered the inclusion of circles, ovals and stars into the street plan, recognizing that they are common devices that can add some embellishment. However, through considerations of convenience and economy, they decided the actual houses should have simple straight sides and right angles.

Simple, formal, rectilinear planning of cities is not new, with precedents tracing back to ancient history. In medieval times too, the bastide towns of southern France, for example, were arranged on a rectangular grid, creating identically sized development blocks on sloping sites as well as flat ones. In New York within the order of a gridiron street pattern there are still countless varying shapes, sizes and styles. Occasionally, there is a contrasting remnant of the past: an old church, perhaps, providing a stark juxtaposition of scale and style.

The tight grain of the city blocks means that streets and avenues cross each other frequently. Cars and pedestrians have to wait for each other in turn at intersections. It's a stop-start process, dictating the rhythm of everyday life.

The play of light differs according to the time of day and the season, and is never more spectacular than when, twice a year, a view of the setting sun is in perfect alignment with the east–west streets of Manhattan. Known as "Manhattanhenge", it happens at the end of May and in mid-July, either side of the solstice on June 21.

While the New York street plan was farsighted in two dimensions, it could not have anticipated the phenomenal scale of vertical development, which has created hot, humid and airless environments. Thankfully, before it was too late, Central Park, inspired by the great parks in European cities, was laid out in an act of great foresight. It now provides New Yorkers an essential 'lung': a release from the relentless, pressurized environment of the city.

Times Square

This informally defined space at the intersection of Broadway and Seventh Avenue takes its name from the *New York Times*, which has had its headquarters near here since 1903. This busy confluence became the focus of Midtown and the heart of the entertainment industry, and the advertising opportunities have been exploited since the 1920s.

With economic decline in the 1970s, this became a 'no-go' area replete with prostitution, pornography selling, drug dealing and gun crime. The downward spiral was reversed by offering preferential rates to chain stores. Today the Square is bright, brash and touristy, with 50 million visitors every year gaping at the 230 illuminated adverts—made of LED panels— on every building facing the Square.

Greenwich Village

Here is a microcosm of Manhattan: a view
looking down on a part of Greenwich Village.
The city blocks are relatively small, creating
an urban environment that is comparatively
permeable, and certainly understandable.

Mature trees line many of the streets and
provide a welcome contrast to the hard edges
and regimented lines.

High Line

This extraordinarily successful linear park, some one and a half miles in length, repurposes the elevated railway, no longer in use, on the West Side. What was once a route to connect places together has now become a destination, acting as a catalyst for the regeneration of the Meatpacking District through which it passes.

The raised line was originally built to separate freight rail traffic from pedestrians and vehicles; these had previously shared the street level, a lethal combination leading to the nickname 'Death Alley'. The line was completed in 1934 and it allowed freight trains to move directly from the docks on the Hudson River to warehouses inland.

When the docks closed the railway became redundant, and it closed in 1980. After lying derelict for years it was reinvented as a raised walkway with informal planting interspersed with the historic structure and rail tracks. The first portion opened in 2009.

Walking along the High Line, I soon realized why New Yorkers like it so much: instead of the usual staccato of walking from block to block, constantly having to wait for the "walk now" sign, here you can stroll unrestricted. Joy!

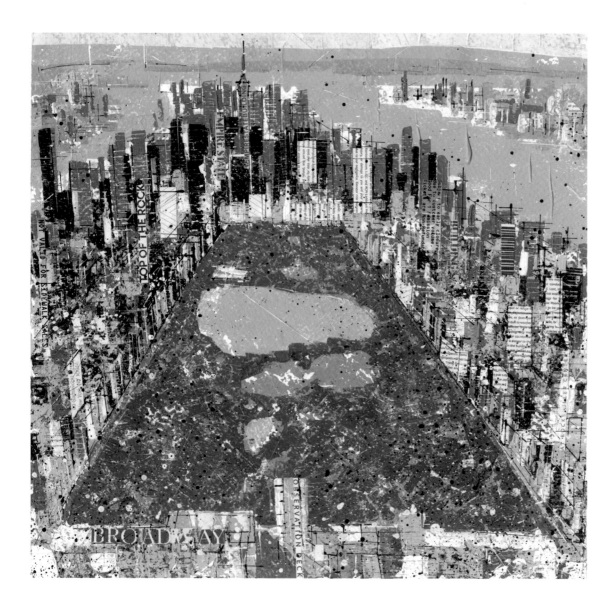

Central Park

By the middle of the nineteenth century Lower Manhattan was characterized by overcrowding, crime and disease. Again, it was farsighted urban planning (with the same foresight that led to the adoption of a gridiron street pattern) that recognized the need for relief in the form of a grand open space like this. The winning entry of a public competition in 1857, the design by Frederick Law Olmsted and Calvert Vaux proposed a wilder garden to the north and more formal gardens to the south, separated by a vast lake.

As a grand civic gesture, this was comparable with the great parks of Paris and London. Today, with most of Manhattan covered by buildings, sidewalks and roads, it is even more valued. Two and a half miles long and half a mile wide, covering 843 acres, it receives some 42 million visitors every year.

The informality of the northern section took me by surprise, particularly for its hilliness. I had assumed that it was all flat. In fact, you can see outcrops of Manhattan Schist, the 380-million-year-old metamorphic bedrock

that lies beneath the city. Hard and durable, it is ideal for supporting skyscrapers—which is just as well.

The terrain of Manhattan was once full of these rugged, rocky outcrops, interspersed with dense woodland and areas of lakes and swamps. This is all hard to imagine as one traverses the flat, paved today.

Sixth Avenue, or Avenue of the Americas
Yellow cabs, seen in countless movies and cherished as a symbol of New York, are under threat from private hire companies and cheaper app-based competitors. Tourists love these distinctive vehicles that surge through the city, but taxi drivers will have to remain competitive and keep pace—not just with fast-moving traffic, but with modern technology.

Sixth Avenue is a major south–north road that runs through the heart of Manhattan, and is notable in its own right as the setting for huge blocks of real estate. From this vantage point, at the crossing of 40th Street, the horizontal lines of the streetscape meet the soaring verticality of commercial properties.

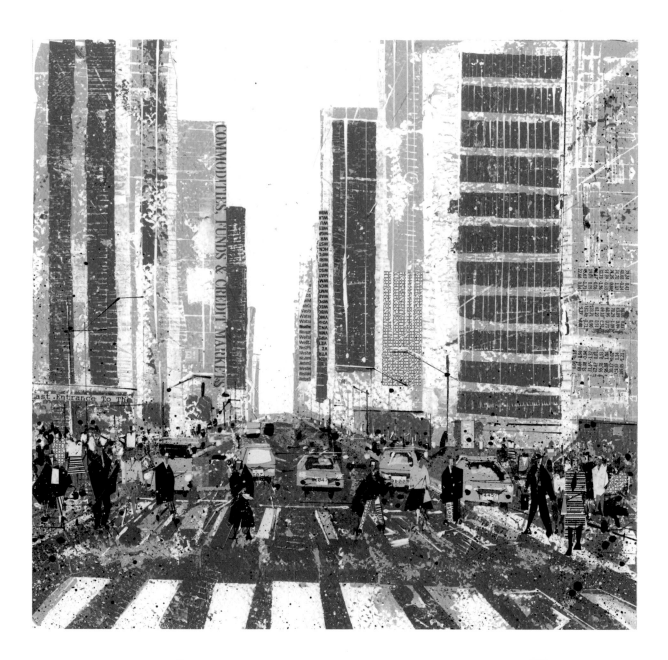

Artifice books on architecture
308 Essex Road
N1 3AX

t. +44 (0)207 713 5097
f. +44 (0)207 713 8682
sales@artificebooksonline.com
www.artificebooksonline.com

Cover: Brooklyn Bridge
Inside Cover: Downtown map
Page 2: Aerial view of the High Line
Right: Sullivan Street
Inside Back Cover: Midtown map

Designed by Mitchell Onuorah
at Artifice books on architecture.

All opinions expressed within this
publication are those of the author and
not necessarily of the publisher.

British Library Cataloguing-in-Publication
Data. A CIP record for
this book is available from the
British Library.

ISBN 978 1 908967 96 1

Artifice books on architecture is an
environmentally responsible company.
Buildings of New York is printed on
sustainably sourced paper.

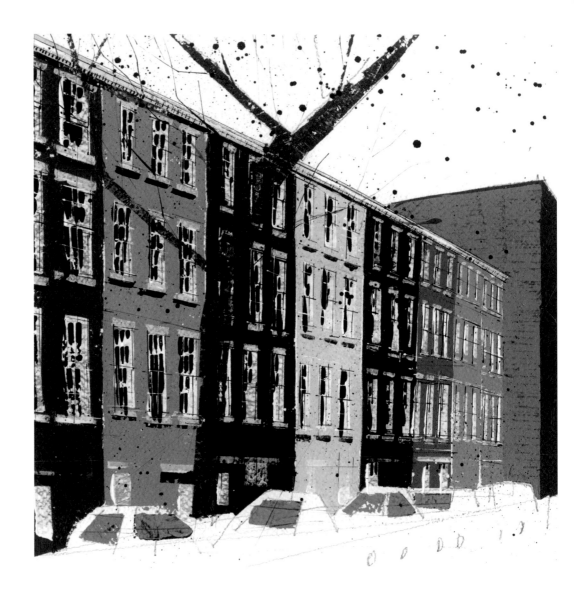